IMAGES
of America
MARSHFIELD

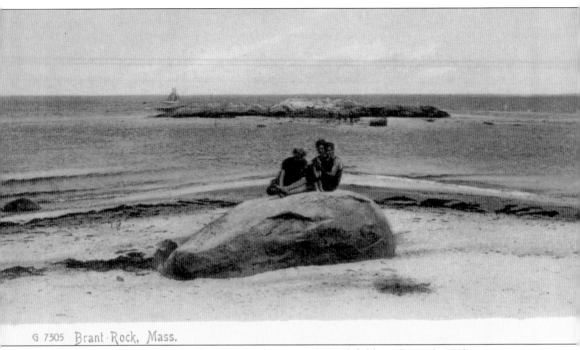

G 7305 Brant Rock, Mass.

If one were to send a postcard of a typical image of Marshfield in the early 20th century, one could hardly go wrong with a beachside shot of Brant Rock.

On the cover: Old timers, like this one reposing at Bluefish Cove, are like good books, yet better. Full of information, fanciful or not, they often are more animated, as this group of young men have come to find out. (Courtesy of Historical Research Associates.)

IMAGES of America
MARSHFIELD

Cynthia Hagar Krusell and John J. Galluzzo

Copyright © 2007 by Cynthia Hagar Krusell and John J. Galluzzo
ISBN 978-0-7385-4572-1

Published by Arcadia Publishing
Charleston SC, Chicago IL, Portsmouth NH, San Francisco CA

Printed in the United States of America

Library of Congress Catalog Card Number: 2006926051

For all general information contact Arcadia Publishing at:
Telephone 843-853-2070
Fax 843-853-0044
E-mail sales@arcadiapublishing.com
For customer service and orders:
Toll-Free 1-888-313-2665

Visit us on the Internet at www.arcadiapublishing.com

*To all lovers of Marshfield and its history,
past, present, and future.*

CONTENTS

Acknowledgments		6
Introduction		7
1.	The Famous and the Founders	9
2.	Blue Seas and Green Harbor	27
3.	Summer at Brant Rock	39
4.	Ocean Bluff, Fieldston, and Rexhame	65
5.	Where the South River Flows	77
6.	With a View of the Sea	91
7.	Along the North River	109
8.	Around the Town that Was	119

ACKNOWLEDGMENTS

The authors would like to thank the following individuals and organizations for their roles in helping to create this book: the Marshfield Historical Commission; Historical Research Associates; Esther Coke; Ken Rand and family; Mass Audubon South Shore Sanctuaries; Natalie Loomis; Peggy Baker and the Pilgrim Hall Museum; Louise K. Talbot; Mary Driscoll; and the many Marshfield residents and other friends of the town's history who have donated their photographs to the town to be preserved for generations to come.

INTRODUCTION

Marshfield is a Massachusetts coastal town located about 30 miles south of Boston and 15 miles north of Plymouth. There are three significant rivers in the town, the North and South Rivers and the Green Harbor River. In the early days of the town, the tributaries of these waterways supplied water power for various milling activities and the North River became a center of shipbuilding. Today the rivers provide recreation and scenic views from homes built along their banks.

The Native Americans knew the area as Missaucatucket and came in the summer to fish and hunt along the shore. The first permanent settlers were *Mayflower* Pilgrims from Plymouth who first came to the southern border of the town by waterway direct from Plymouth. Soon the settlers began to use an old Native American trail as a land route. They called it the Green's Harbor Path after William Green, one of the first comers to the beach area, still to this day called Green Harbor. Today we call this ancient way the Pilgrim Trail.

The two prominent early landholders of the town were the Winslow and Thomas families. They founded the town in 1640, established the first church and started one of the earliest publicly funded schools in the country. The two families lived on their large estates for about five generations until the time of the American Revolution. Some members became patriots and fought for the colonies; others were loyalists or Tories and sided with England. Many of them held important positions in the town, county, and state governments over the years. Other prominent families included the Whites, Littles, Bournes, Watermans, Dingleys, Rogerses, Macombers, Trouants, Phillipses, Rouses, and Bakers.

The town grew in population and developed industries and institutions. Gristmills and sawmills sprang up along the waterways. An early iron works was established on Furnace Brook. Shipbuilding began on the banks of the North River at several sites. Later came cotton mills on the South River and nail and tack factories in various locations. A number of different church groups were gathered, and soon the First Congregational Church was joined by an Episcopal church at Center Marshfield, a Baptist church at Standish, a Methodist church on Zion's Hill, a Unitarian church at Marshfield Hills and, in time, Catholic churches and a Christian Science church. District schools were eventually established in 12 different locations in the town and these evolved into today's large school system with elementary schools, a middle school, and a senior high school.

Famous statesman and orator Daniel Webster chose Marshfield as his home. Arriving in 1832, he purchased the old Thomas estate from John Thomas and soon became known as the "Farmer of Marshfield." He acquired additional land and put together a farm of some 1,800 acres. He

developed extensive produce gardens, raised and bred varieties of cattle and horses and other farm animals, imported different species of plants and trees, and eventually had an outstanding arboretum. Webster encouraged local farmers to improve their crops and farmers' fairs were held on the town training green, a forerunner of the now famous Marshfield Fair. Meanwhile, Webster continued to serve as a U.S. congressman and was a U.S. secretary of state under three presidents. Prominent statesmen visited him in Marshfield where they conferred in Webster's Law Office over matters of state. Webster died here in 1852 and is buried in the old Winslow Cemetery adjacent to his home. Many dignitaries came to his funeral. The crowd was said to have numbered over 3,000 people who arrived either by train, carriage, or boat.

Other famous people in the town included Adelaide Phillips, a world-renowned concert singer, and Reginald Fessenden, who broadcast the world's first voice radio program from Blackman's Point on Christmas Eve 1906.

Marshfield became known as a summer resort in the late 1800s when the railroad was extended to the town and people could easily come from Boston. A number of hotels were built in the beach areas of Green Harbor, Brant Rock, and Sea View. An early Massachusetts Humane Society shelter stood at Brant Rock, followed by the U. S. Life Saving Service and then the U.S. Coast Guard. The idea of a service to help shipwrecked sailors started along this area of the Massachusetts coast. The Coast Guard Station was removed in 1967 when service was discontinued at this location.

Marshfield is today a so-called bedroom town of Boston. It still retains its boating and fishing interests, but mainly as recreation. The population now stands at about 27,000 and housing developments have sprung up in every area of the town. In many ways, however, the town retains its original character, and there are quaint, quiet villages still to be found in the midst of the present-day explosion of population and rapid industrial development.

One

THE FAMOUS AND THE FOUNDERS

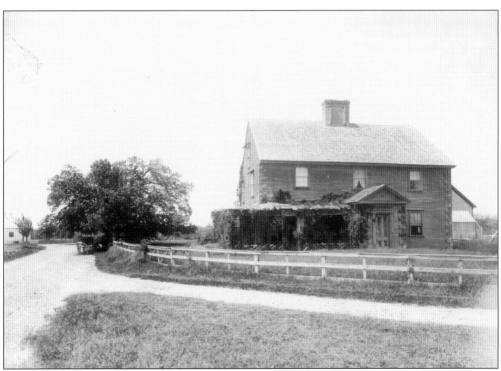

The Isaac Winslow House is a good place to start. Built about 1699 by Isaac Winslow of Marshfield's founding family, this house has witnessed more than 300 years of the town's history. The first two generations of the Winslows lived in a location slightly south of here. Careswell Street leading into Marshfield today is named for the Winslow ancestral home in England.

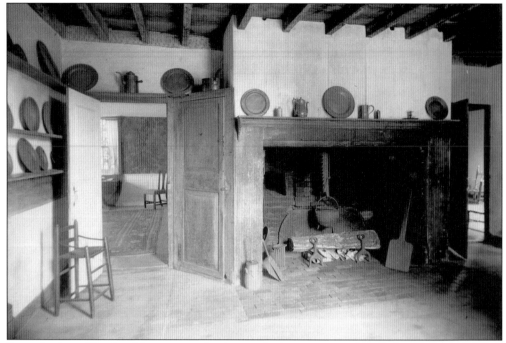

Enter the Isaac Winslow House winter kitchen and take a giant step back in time. The cavernous fireplace with its beehive oven is especially impressive. Here the array of old kitchen utensils and equipment remind current generations of the hard work required of their ancestors. Adjacent stone steps descend to the dairy while other steps lead up to the buttery.

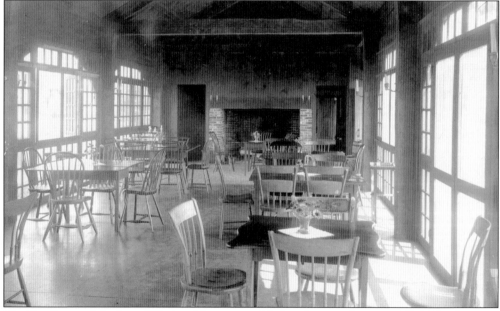

The Tea Room of the Isaac Winslow House was added to the main house in 1920. This long tea room with its many windows was a luncheon spot during the 1920s and 1930s. The restaurant helped to raise money for a major restoration of the house at that time. The old well, at one end of the room, was once located outside the building.

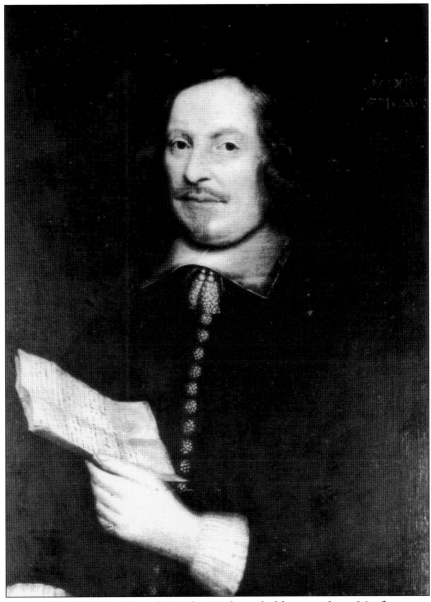

This portrait of the Pilgrim Edward Winslow is the only likeness of any *Mayflower* passenger. Winslow served Plymouth Colony in many capacities. He was appointed governor of the colony three times and was assistant governor many times. He was the principle negotiator in the affairs between the Pilgrims and the Native Americans and became Plymouth's ambassador to the Bay Colony at Boston and to England. His journal, *Mourt's Relation*, is a rich source of information on the activities of Plymouth Colony. Born in Droitwich, England, his family was thought to be of the landed gentry class. He was educated at King's School, Worcestershire, and apprenticed as a printer in London. In 1617, he joined the Pilgrim Separatists in Leyden, Holland, before embarking on the *Mayflower* in 1620. He first came to Marshfield in 1632. Settling here permanently in 1636, he founded the town in 1640. With him came his wife, Susannah White Winslow, two stepsons Resolved and Peregrine White, and his own son Josiah, born in 1628 at Plymouth. (Courtesy of Pilgrim Hall Museum.)

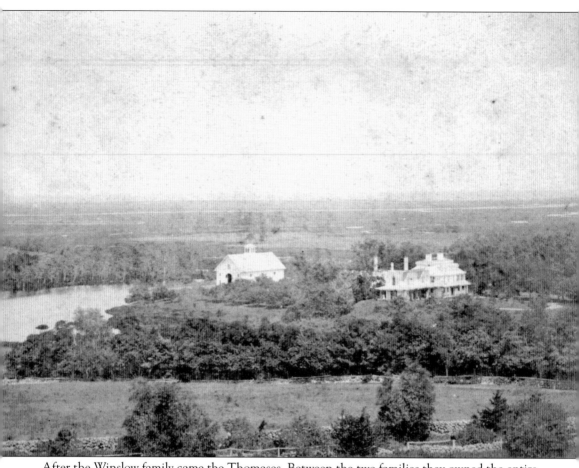

After the Winslow family came the Thomases. Between the two families they owned the entire south end of Marshfield. William Thomas was granted 1,500 acres in 1645. His estate bordered the Green Harbor River valley and included what is today the Massachusetts Audubon Society's Daniel Webster Wildlife Sanctuary, as well as Black Mount and the Green Harbor Golf Course. He gave the land for the Winslow Cemetery to the town. Nathaniel Ray Thomas of the fifth generation was a Tory at the time of the American Revolution. He served with the British government in Boston as a mandamus counselor. Fearful of the growing number of patriots, he ordered British soldiers to be sent down from Boston and quartered at his home, but was forced to flee when local patriots threatened to seize him. Had the patriot troops gathered sooner to attack the Thomas estate, the first battle of the American Revolution might well have occurred in Marshfield. Nathaniel Ray's son John turned patriot, and it was he who sold the estate to Daniel Webster in 1832.

Here is the old road to the Thomas/Webster house. The road is a part of the Green Harbor Path, an ancient Native American way that led from Plymouth to Scituate. Known today as the Pilgrim Trail, it was laid out in 1637 as one of the first court-ordered roads in America. British soldiers ordered by Nathaniel Ray Thomas marched here in 1775. Webster called it "The Avenue."

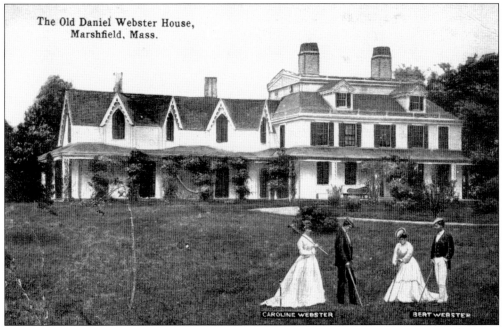

Webster loved his home in Marshfield. When in Washington, he longed for "Marshfield, oh Marshfield, the tall elms and the sea." He added a gothic library wing, designed by his daughter Julia, to the 1774 Nathaniel Ray Thomas home. Here he could be with his family and friends and hear "the ocean lapping at his garden wall."

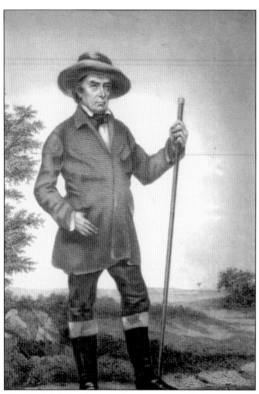

Daniel Webster called himself the "Farmer of Marshfield." He loved to oversee his extensive estate, clearing fields, planting crops, experimenting with crop rotation, fertilization, and livestock breeding. He encouraged local farmers to compete and was an inspiration for the later Marshfield Agricultural Fair. He created an arboretum of exotic trees and plants, some of which can still be seen today.

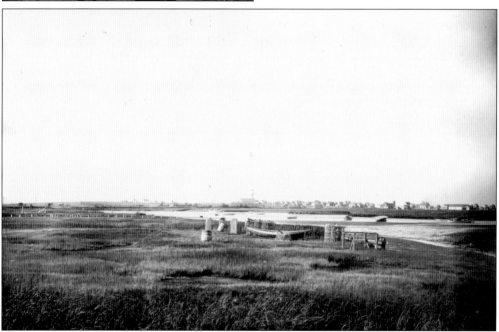

Here at Webster's Landing on the Green Harbor River the great statesman would board his little sloop *Lapwing* for a day of fishing off Brant Rock. Accompanied by his boatman and sporting companion Seth Peterson, Webster delighted in fishing and hunting. With the Green Harbor marshes and the sea at his doorstep, the life of the sportsman was readily available.

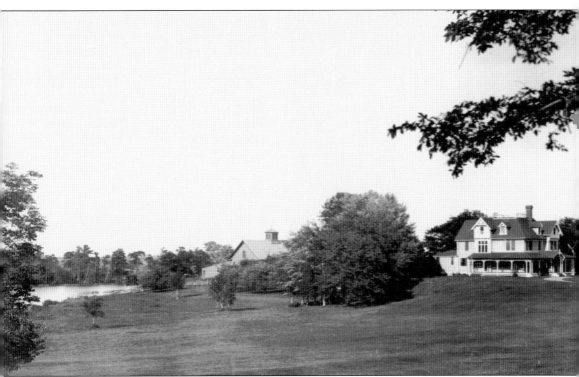

The house that Webster knew and loved burned in 1878, about 25 years after his death in 1852. The Second-Empire, Queen Anne–style house shown here was built in 1880 and is still standing today. It was designed by the well-known architect William Gibbons Prescott and overseen by Webster's daughter-in-law, Caroline White Webster, widow of his son Col. Fletcher Webster. Fletcher was killed in 1862 at the Second Battle of Bull Run in the Civil War. Caroline had the house built on the foundation of the old house and incorporated symbols of Daniel Webster's life. Under the mantel of the entrance hall fireplace there is a model of a sheaf of reeds representing the Union of the states, a subject dear to Daniel's heart. Other symbols include coats-of-arms, one in the stained-glass window and another on the front facade of the house. The barn shown here is the old Webster-era barn that later burned. Caroline continued to live in the house until the estate was bought in 1884 by Walton Hall.

This sweeping view of the Webster Estate taken from the foot of Black Mount shows a large area of the Webster landholding. In an attempt to reestablish the acreage that originally belonged to both the founding Winslow and Thomas families, Daniel Webster acquired considerable land during his years in Marshfield. He eventually owned 1,800 acres including the Isaac Winslow house. He built an observatory on the crest of Black Mount, grazed llama on the hillside, and

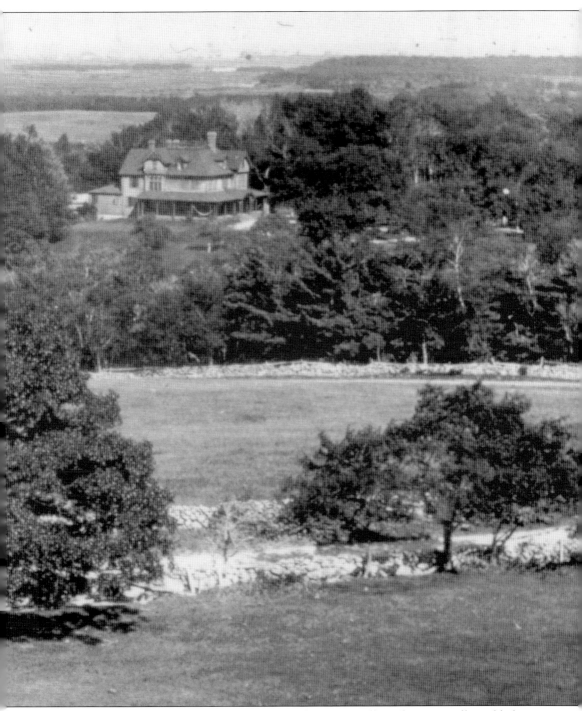

grew potatoes and onions in the fertile Green Harbor River valley. The stonewalls visible here mark the bounds of Webster's tillage and grazing fields. These fields were used for tents to house the multitudes of people who came to the grand 1882 centennial celebration of Webster's birthday. Among the visitors were Pres. Chester A. Arthur, his wife, Ellen Arthur, and Secretary of War Robert Todd Lincoln.

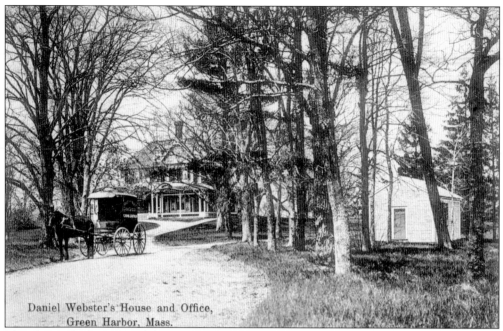

Daniel Webster's House and Office, Green Harbor, Mass.

This shows the location of the 1842 Webster Law Office when it was on his estate. A granite marker indicates the site today. The office was moved to the grounds of the Isaac Winslow House in 1965 and is today a designated National Historic Landmark. Daniel Webster called it his horticultural library. Here he met with visiting dignitaries including Canadian Lord Ashburton, with whom he drew up the Ashburton-Webster Treaty, setting the bounds between the United States and Canada.

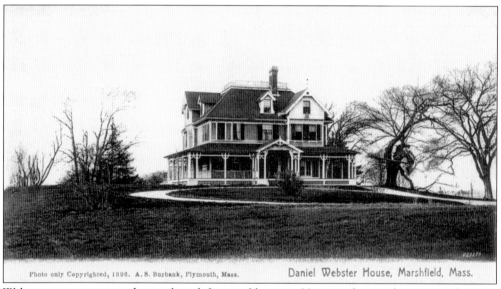

Photo only Copyrighted, 1896. A. S. Burbank, Plymouth, Mass. Daniel Webster House, Marshfield, Mass.

Webster was an outstanding political figure of his age. He served several terms in the U.S. House of Representatives, was a senator from 1827 to 1840 and again from 1845 to 1850, and was secretary of state under Presidents William Henry Harrison, John Tyler, and Millard Fillmore. He is most famous for his debates in Congress where he argued for the "Union, one and inseparable, now and forever."

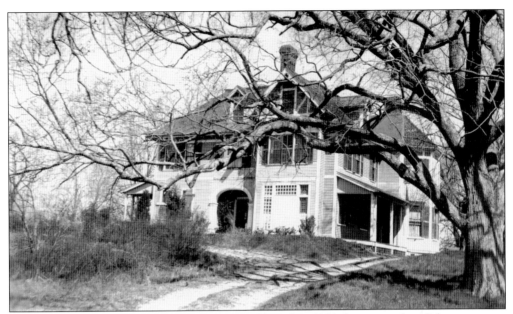

After Webster's death, much of his land was sold, and in 1884 the remainder of the estate was bought by Walton and Ella Lincoln Hall. The Halls acquired additional land and maintained the estate much as it had been in Webster's time until the 1940s. From 1950 to 1990, it became the Daniel Webster summer camp. Acquired by the Town of Marshfield in the early 1990s, the house has been restored and is now managed by the Daniel Webster Preservation Trust.

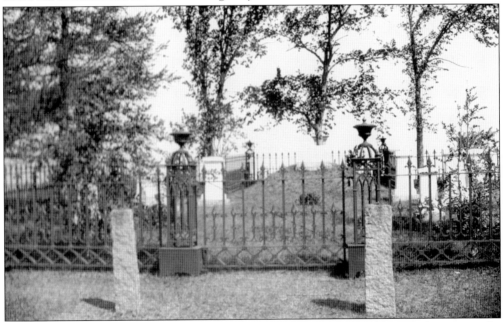

More than 3,000 people attended Webster's funeral in October 1852. They came by carriage, by boat, and by train to the Kingston Railroad Station. It is said that one could see the dust rising from the dirt roads for miles around. Webster chose to be buried in the old Winslow Burial Ground adjacent to his beloved home rather than in the National Cemetery in Washington. His tomb and family plot can be visited today.

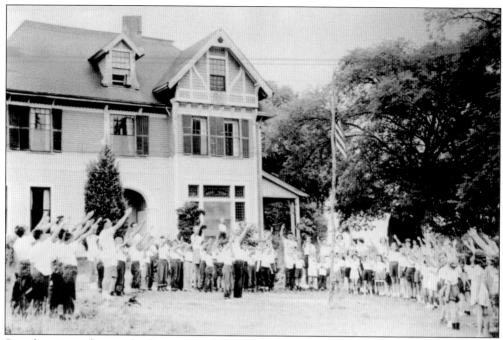

Seen here is a salute to the flag at Camp Daniel Webster. Daniel Webster would have approved of this patriotic act. The Hall family sold the estate to Vincent Cohee, who started the popular summer camp in 1950. In 1966, James and Phyllis Anderson acquired the property and continued the camp for the next 20 years. The extensive grounds provided a perfect setting for camp activities.

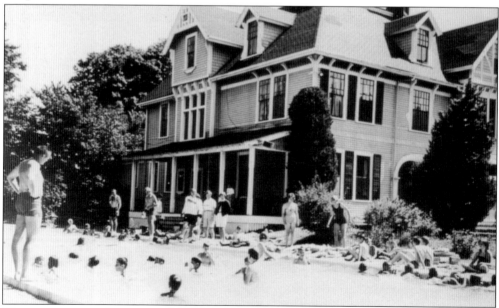

The construction of a swimming pool where Webster's gothic library had stood significantly intruded upon the original integrity of the estate. The campers were delighted, however, and the camp became famous for its swimming programs. The fine bracketing and stick-work detail of this Queen Anne house can be readily seen here.

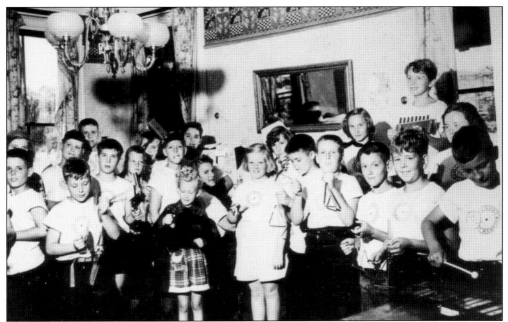

In this image, it is time for a music lesson in the music room of the mansion. The camp utilized both the house and grounds of the estate. The spacious rooms in the house offered convenient areas for indoor activities. Here can be seen a piece of the original wallpaper at the top of the wall above the mirror. Fortunately this has survived as one of the only decorative items from the 1880 house.

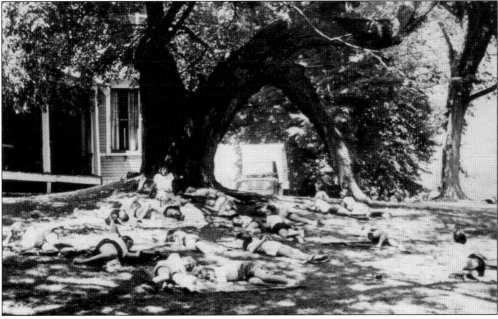

Seen here is nap time under the old elm tree at the Camp Daniel Webster. To British soldiers stationed here during the days of the American Revolution, this tree was known as the "whipping tree." Bad actors were tied to the tree and lashed for misbehavior. One must wonder what these napping children are dreaming about.

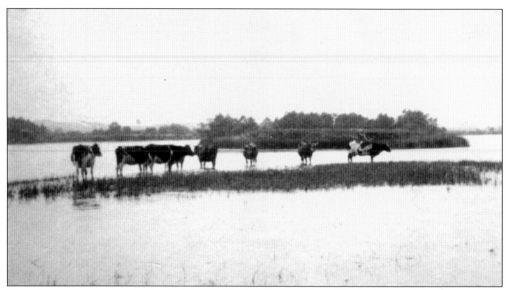

Here the cows graze in the flooded Green Harbor River valley. The building of the dyke in 1872 altered forever this river and marsh. The construction of the dyke provoked much controversy. The fishermen opposed the closing of the upper reaches of the river to fishing while the farmers agitated to create more fertile farm land. Although the farmers won, it is said that there have been several secret attempts to blow up the dyke.

If this were one of Daniel Webster's cows, he would have a name for her, as he did for all his cattle. As he lay on his death bed, he had his farm hands parade his cattle past his window and said goodbye to each of them by name. It was said that Webster buried his horses standing up with their halters on out of respect for them. The discovery of horse graves in 1979 proved the tale to be right.

After Webster's death, much of his property was auctioned off and the area now known as the Daniel Webster Wildlife Sanctuary was bought by a succession of people including Edward White and Edward Dwyer. The house and silo shown here were some of the original buildings on the Dwyer Farm. In 1984, the property was acquired from Dwyer by the Committee to Preserve Dwyer Farm for the People of Marshfield, who then turned it over to the Massachusetts Audubon Society.

The old barns and outbuildings of the Dwyer Farm are testimony to the years of husbandry connected with this rich farm land. The continuing history of farming on Webster's land would have pleased him, who was himself so interested in agriculture, stock raising, and wildlife. The inspiration for John James Audubon's painting of geese came from a hunting expedition with Webster at Green Harbor.

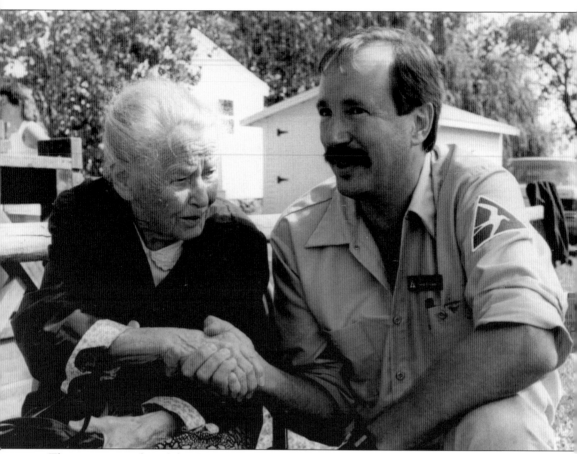

The existence today of the 507-acre Daniel Webster Wildlife Sanctuary is due in large part to Dorothea Reeves and David Clapp. As a team they accomplished a seemingly impossible task. Reeves was wholly dedicated through the 1980s to the project of obtaining the Dwyer Farm for conservation purposes. She was responsible for organizing the Committee to Preserve Dwyer Farm for the People of Marshfield. Eventually the money was raised and the farm bought. Clapp arrived as the Massachusetts Audubon Society's director of the South Shore sanctuaries just in time to manage the development of the farmland into the sanctuary it is today. He was responsible for laying out trails, building board walks, creating wetland areas for wildfowl, and designating viewing areas. Nature programs and wildlife walks became regular activities.

Farm Day at the Daniel Webster Wildlife Sanctuary has become a popular event and draws crowds from far and wide. It is still today a celebration of harvest time with hay rides, booths of tempting things to buy, corn husks, pumpkins, apples, and farm produce. The celebration provides a time to reflect on life as the Thomas and Webster families and the White and Dwyer farmers knew it.

Meet David Ludlow on his tractor, a familiar scene during the 1990s. As the caretaker of the Daniel Webster Wildlife Sanctuary, he kept it all together, mowed the fields, kept the trails open, put up the purple martin boxes, and kept the geese under control. He brought a sense of fun and good spirit to the growing years of the Daniel Webster Wildlife Sanctuary.

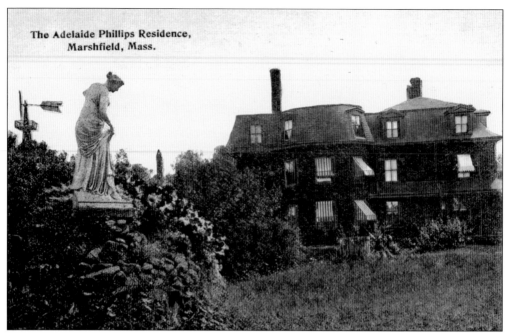

Once the home of world-famous opera singer Adelaide Phillips, this elegant mansard-roofed house on Webster Street burned to the ground on July 9, 1990. Phillips arrived in Marshfield in 1860 with her three brothers, a sister, and an adopted sister. They created an elegant estate with extensive flower and vegetable gardens and orchards. Her brother Alfred had a garden conservatory where he raised flowers for the Boston market.

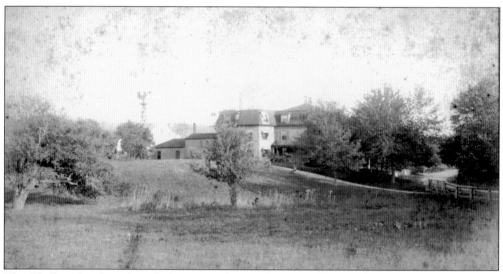

The Phillips family enlarged the original 1850 house, adding ells and outbuildings. They employed a coachman, housekeeper, and cook. Alfred Phillips raised a record quantity of hay that was stored in the large barn. The family had many dogs and other animals and engaged in a social round of "orchard parties," musicals and dancing. A considerable trust fund was set up by Adelaide Phillips before her death to care for her siblings.

Two

BLUE SEAS AND GREEN HARBOR

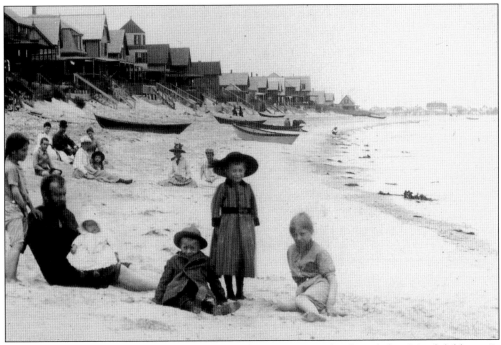

William H. Marnell, author of *Vacation Yesterdays of New England*, said that Marshfield was "a battleground between rock and sand," that the town had a little bit of the Cape Cod shore to it, and a little bit of the Maine coastline as well. But, he said, "there was one blessed part of Marshfield . . . that was always sandy." That place, named for Marshfield's first known settler, William Green, was Green Harbor.

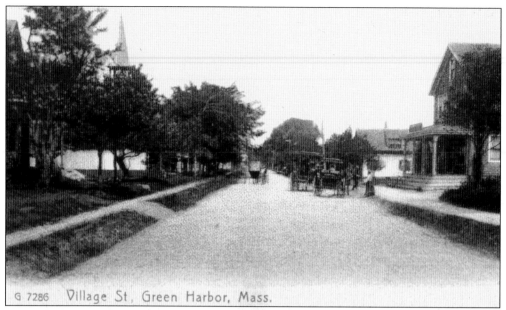

Green Harbor was the first of the many geographically defined and philosophically independent communities within Marshfield, chronicled in Cynthia Hagar Krusell and Betty Magoun Bates' *Marshfield: A Town of Villages*. It was places such as here, on Marginal Street, that the business of Green Harbor was done, from religion, to peddling, to all-important gossiping about town government.

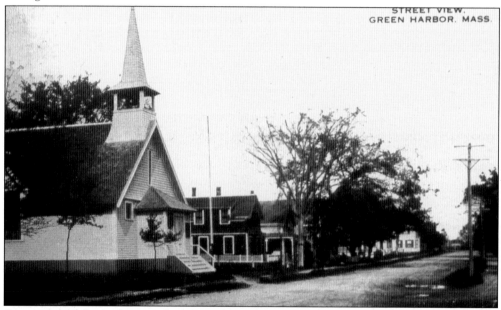

Grace Chapel, shown here on the left, spoke to the growth of the village. The Unitarian Grace Chapel Society formed in 1882, meaning, simply, that the population of Unitarians in the area had grown sufficiently to warrant the construction of a church, and later, in 1903, a parish house. Joseph C. Hagar notes in *Marshfield: The Autobiography of a Pilgrim Town* that "Reverend Mary E. Leggett, who came in 1891, awakened great interest among the residents of Green Harbor and Brant Rock."

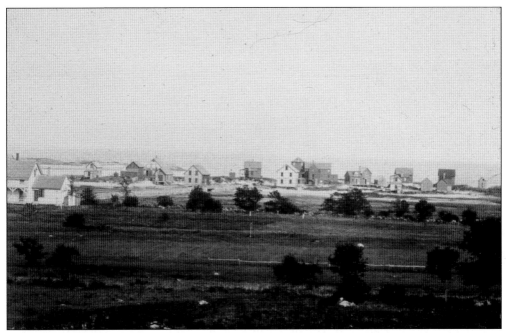

Settlers approaching the Marshfield shore looking for a good place to build a house in the 1600s would have chosen spots like Green Harbor, as much of their worldly goods would come in trade from England. Quick access to a working port would have been crucial to survival. Those same lots were just as popular 200 years later, as Victorians sought the salty air, sandy beaches, and melodic sounds of the sea that places like Green Harbor offered.

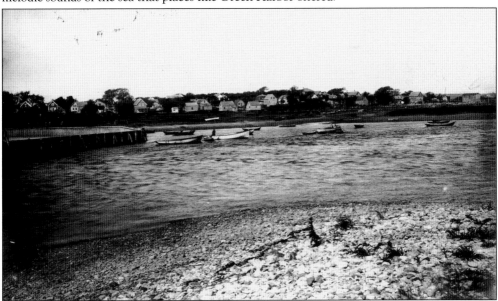

And so it was that Green Harbor meant many things to many residents and visitors over the years. While some folks looked out onto the waters and saw the tools of their livelihood—in fishing, lobstering, and Irish mossing boats—others saw the tools of recreation, small water craft that freed them from the shackles of the land. Marginal Street runs across the far side of the water in this picture.

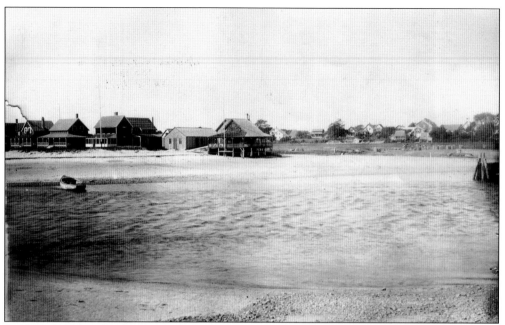

In 1871, the Green Harbor River, through no fault of its own, caused quite a controversy in town. The construction of a dyke inhibiting the outflow of water to the sea, a boon to salt-marsh hay gatherers in the area, led to the silting up of the harbor, a problem of no minor consequence to the fishermen of the area. In just a few years, businesses died, arguments at town meetings escalated to reach the courts, and a lone dynamite-toting "anti-dyker," as the structure's opponents were known, tried to blow it out of existence.

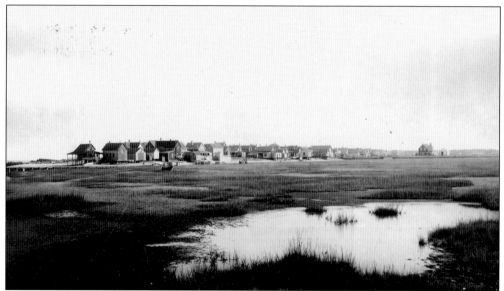

Of the three types of grass known as salt hay on the East Coast, Marshfield has the saltiest and therefore the highest quality *spartina patens*. The grass provided good feed for cattle, thatching for roofs on early homes, and garden mulch. While farms still existed in great numbers in Marshfield, a good harvest of salt-marsh hay was worth a day in the marshes up to the knees in mud and water.

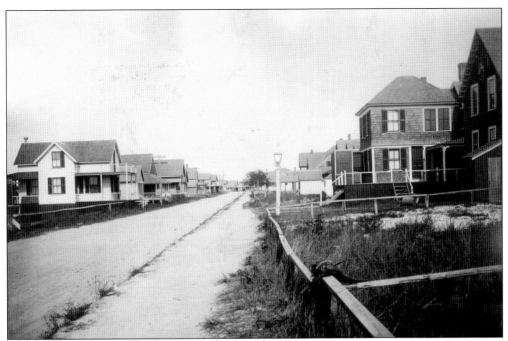

For most summer visitors to Green Harbor, the dyke feud was a fight for the locals to decide. Mostly those visitors hoped for warm, calm days on their front porches on Bay Avenue, one of the most prominent of the byways of the region. Porches represented a change from an agrarian to an industrial American economy. Increases in technology brought automation and factories, and factories created the six-day, then five-and-a-half-day, then five-day workweek.

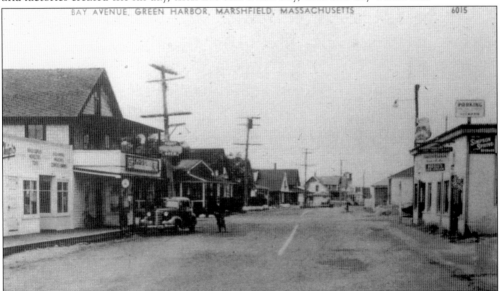

The five-day workweek meant two days away from the factory, and with no farm work to tend to, Americans could finally take time off. That came in many forms. For some, that meant lounging on the porch at home. For others, it meant buying or renting a summer home along the shore, where the action was. Here Bay Avenue shows yet another transformation in American society, from horse-drawn wagons and dusty roads to automobiles and paved streets.

Beach Street, which runs today between Careswell Street (Route 139) and across Canal Bridge to Bay Avenue and beyond, gave early settlers and travelers access to the coast. Such roadways were important to those folks seeking regeneration from the supposedly salubrious waters of the Atlantic, in an age (the early 19th century) when doctors prescribed salt water swimming as a curative for all sorts of ills.

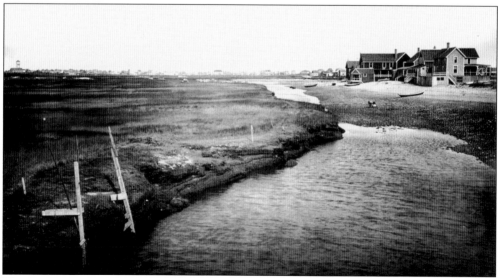

The Cut River is smaller than the Green Harbor River, and, yes, smaller than the North River, but nevertheless makes for an interesting study of human impact on the Marshfield landscape. Silted shut by nature, the river was reopened by the digging of a canal in the first decade of the 19th century, reinvigorating the flow of water from the Green Harbor River to Duxbury Bay, to the south.

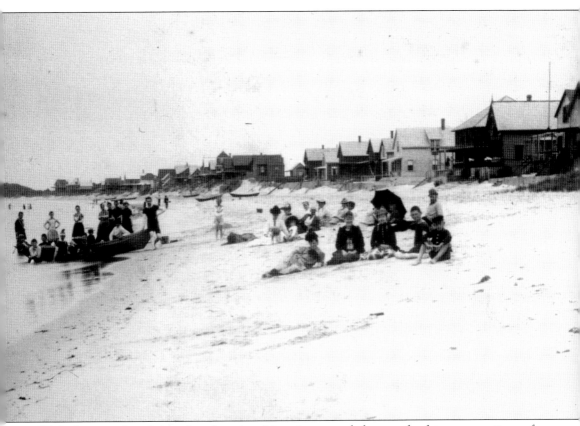

With their newfound time for relaxation, Victorians paved the way for future generations of beachgoers with their day trips, weeklong stays, monthly sojourns, and seasonal retreats to the shore. "The concept of the private beach was unknown in Scituate and Marshfield," writes William H. Marnell, and he is almost right. While Cohasset's shoreline is mostly exclusively presided over by private individuals, a visit to Duxbury's barrier beach comes with a price for parking access, as at Marshfield's beaches (the residents of Rexhame Beach have long considered that space as private). Proper ladies wore dresses to the shore in the 1880s, while young men were free to wear less material. Over the years, one could watch as bathing suits grew smaller and smaller, until men lost their tops altogether, and women lost their dresses for form-fitting bathing costumes. One can only wonder what a late-19th-century visitor to Green Harbor Beach would think visiting his or her favored seasonal spot today.

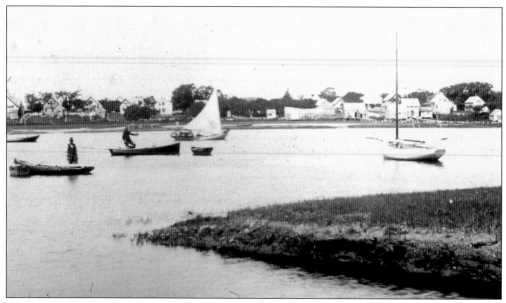

Sitting on the beach, whether yesterday or today, comes with its share of simple pleasures. Although motors have forever changed the way Americans move on the water, the simplest methods of propulsion, shoulder-driven and wind-powered, are still prevalent today. This scene on the Green Harbor River around the end of the 19th century has not completely faded from Marshfield today.

Of course, the growth of the industrial sector in Massachusetts has changed the way a young man of Marshfield thinks about his future in comparison to how his great-grandfather did. The fact is that due to the transient nature of the American worker today, the great-grandfathers of today's residents probably never even knew Marshfield existed. If a young man had grown up in Marshfield in the 1800s, though, as for instance the young man with the oar here on the Cut River, he would have dreamed of being what his father and grandfather had been before him: captain of his own boat.

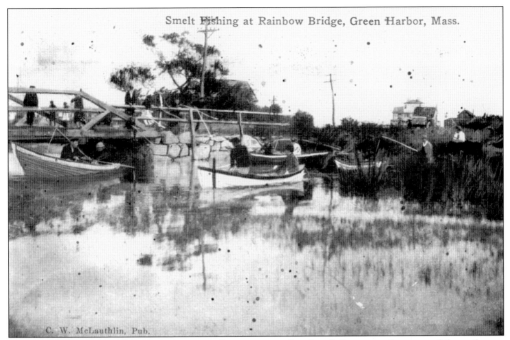

Smelt fishing in Marshfield was a rite of spring, as schools of these anadromous fish, at home in either salt or fresh water, raced up the Green Harbor River each year. Usually growing to no more than six inches in length, smelt made for a delightful seaside meal, fried and eaten whole.

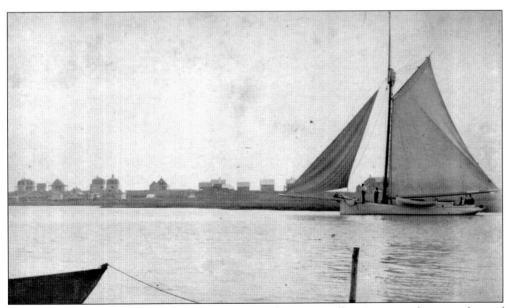

Sailing as a means of transportation began more than two millennia ago; sailing as a form of recreation evolved here in the middle of the 19th century. This scene, in Green Harbor with Brant Rock in the distance, was typical of a summer's day all along the South Shore in the late 19th century.

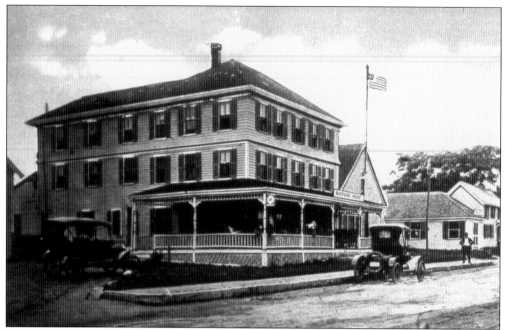

When trains rumbled to stops along their tracks, before the arrival of the automobile, they inevitably delivered passengers to places like the Riverside House, formerly the Sears Hotel and later the Riverside Inn, on Marginal Street. Here summer revelers and fall sportsmen alike could find all they needed, from food, to transportation, to even possibly a telephone in the lobby.

The Albert Inn at 13 Beach Street, formerly the Mabel Cottage, was a similar destination, where proprietor Albert G. Flanders promised his guests the fulfillment of their vacation wishes.

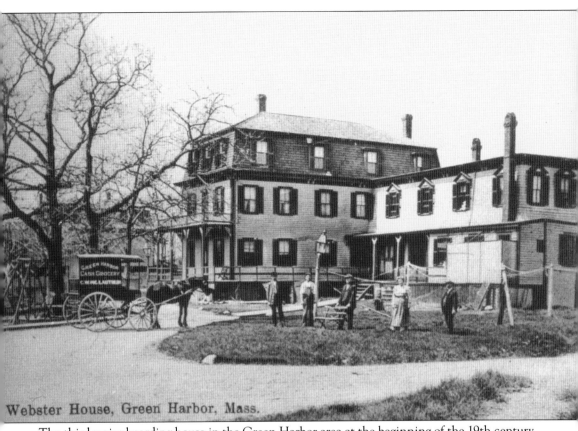

Webster House, Green Harbor, Mass.

The third major boarding house in the Green Harbor area at the beginning of the 19th century was the Webster House on Careswell Street. Built in second empire–style with a Mansard roof, the Webster House—obviously capitalizing on the romantic connection between the town and the statesman for whom the hotel was named—was typical of its day. Among the amenities of which its patrons could partake was the delivery of fresh, cash-on-the-spot groceries, an important feature in the days before refrigeration. And, while their establishments sat not directly on the beach, hoteliers like the proprietors of the Webster House could arrange for quick access to it at any time, when quick meant a dusty ride down a dirt road in a horse-drawn carriage.

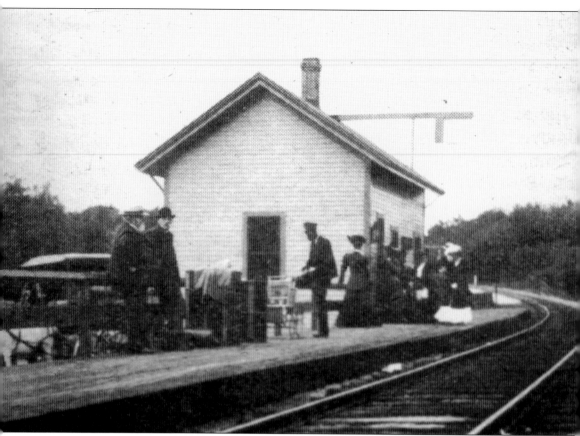

As stated previously, many of the travelers that discovered the Marshfield coastline as the place to be in summer did so by following the path of the New York, New Haven, and Hartford Railroad. Families traveling from Boston and beyond and headed for the Green Harbor hotels brought their clothes, a stack of good books, and whatever else they needed for the summer. Families with summer homes packed their furniture into private cars and even made arrangements for their servants to come along. And the same train that brought them into town around Memorial Day took them away from the Green Harbor station, shown here, around Labor Day. Green Harbor would be returned to the locals for the colder months, and the cycle would turn around again.

Three

SUMMER AT BRANT ROCK

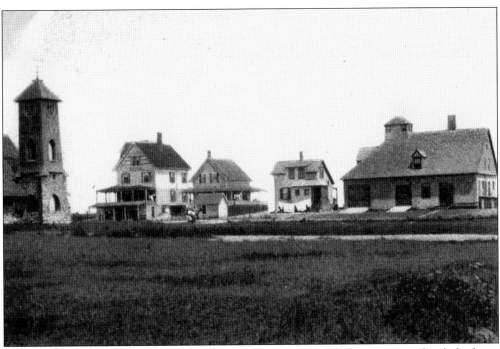

If one wanted to see Marshfield in its glory at the end of the 19th century, and only had one day to do so, that day would have to be spent in the village of Brant Rock. While the average summer day tripper to the South Shore might be interested in the history of the Winslows and the Websters, and might be pulled north to Ocean Bluff and its casino, Brant Rock had what one really wanted: sand, pool tables, ice cream, dancing, the works.

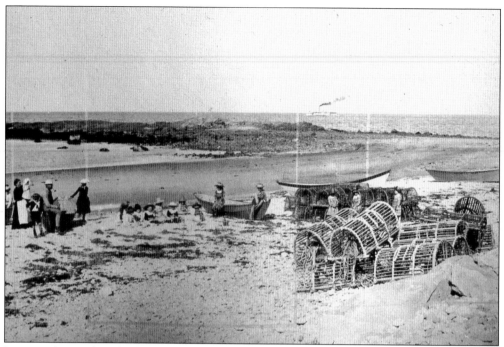

Lest one forget, though, that year-round residents did live at Brant Rock, the locals made their presence known. Boiled shore dinners had to be supplied to the hotels by somebody, and that somebody was the Brant Rock lobsterman or fisherman.

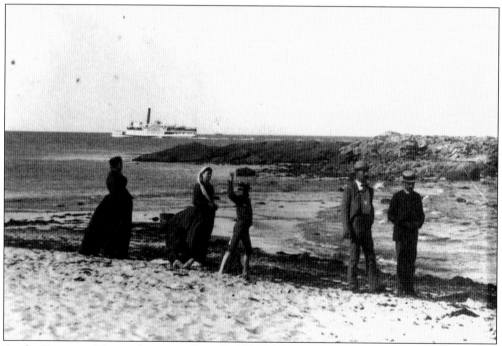

As the Boston-to-Plymouth steamer *Priscilla Alden* glides past in the background, a small group experiences a breezy day in front of the rock for which the village is named, Brant Rock. A brant is a small member of the goose family and favors such habitats as the oceanfront provides.

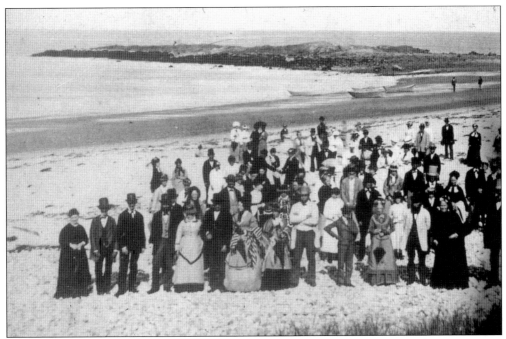

The beach itself, of course, could accommodate a gathering of almost any size. A favorite pastime of many church groups of the day was a return to nature, and a day at the shore at Brant Rock provided just such as escape.

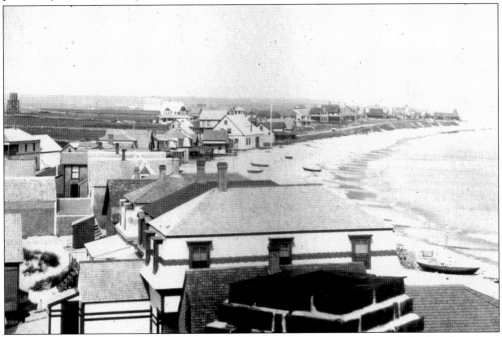

Looking north toward Hewitt's Point, one can see the majestic sweep of the beach, not to mention the presence of the federal government at the Brant Rock Life Saving Station, with the light-colored peaked roof. At top left, the fields at Ocean Bluff remain undeveloped for the moment.

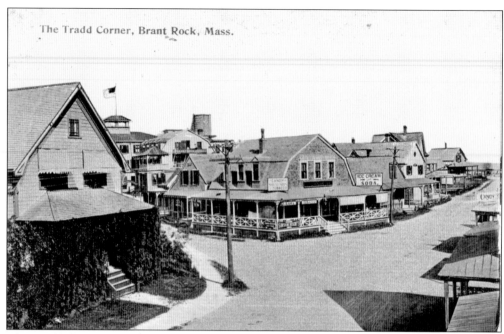

The Tradd family took advantage of the rapid growth of Brant Rock as a seaside resort in the early 1900s by setting up shop at the Silver Lake House on Middle Street, and later opening the Rockwood Inn at the corner of Ocean and South Streets.

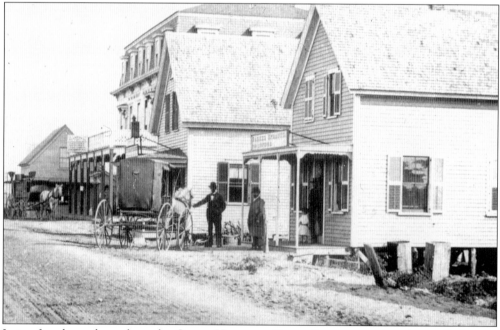

Just a few doors down from the Ocean House on Ocean Street, a carriage has pulled up in front of an establishment in search of supplies. Progressive businessmen, as many hotel owners were known to be, practiced vertical integration, owning surrounding buildings for alternative revenue streams. The Peterson family, for instance, ran the Ocean House and the grocery next door, among other businesses.

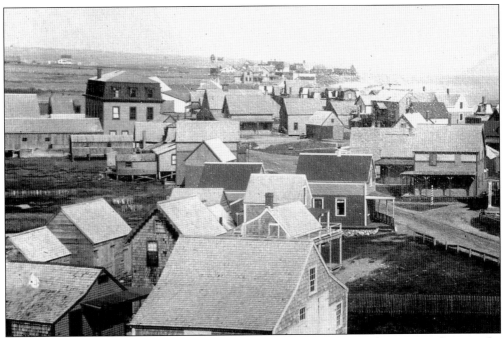

A view across the rooftops of Brant Rock, looking north, offers a chance to reflect on the progress of development in Marshfield. Although there are a greater number of homes in the region today, there were, as everywhere else, more structures per home on the land in the early 1900s, as horses needed to be housed, and various other outbuildings were needed for ice, coal, and other items.

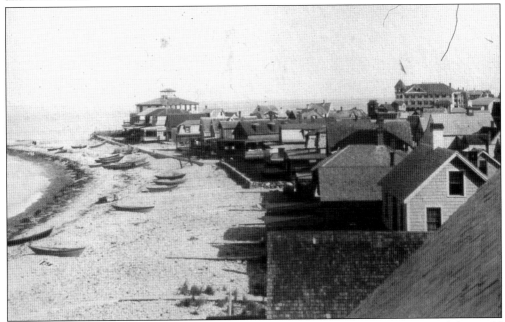

The residents of Brant Rock would hardly believe it today, but their little corner of the world once supported several large hotels, or at least large by the standards of the day. Looking south along the beach, one sees the Brant Rock House, and at the far right, the Hotel Churchill.

Travel into and out of Brant Rock village, other than by sea, was accomplished by means of horse and carriage. Stagecoaches and long, open-air carriages known as "barges," the buses of their day, ran to and from local train stations. All the horses traveling the roadways needed a place to spend the night, as at the stable above. Note the cow wandering the street besides the building, a common sight in Brant Rock in the late 1800s.

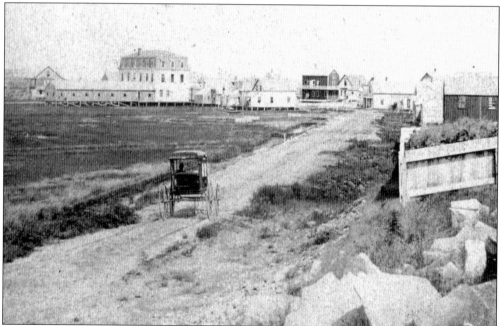

The conditions of local roads had barely changed since the arrival of the Pilgrims in Plymouth in 1620. The roads were dusty in summer, frozen hard in winter, and muddy in spring. A carriage ride down Island Street (the Ocean House is on the left) came with its share of potential frustrations.

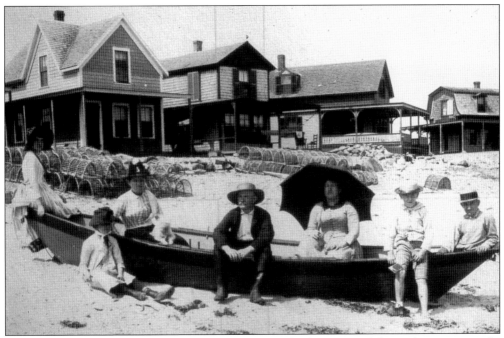

The arrival of the trains connecting Boston to the South Shore created the working vacation for the Boston businessman spending time on the shore. A father or husband could hop on a train to the city in the morning and return to Brant Rock in time to catch the sunset and enjoy the pleasures of an evening on the beach. The entire family unit could take advantage of the season while the man of the house kept his paycheck coming in.

Looking for a summer romance, the young ladies (and one young gentleman) of the Brant Rock shore needed to look no further than Lovers' Rock, pictured here. Geological features along the shore, like Brant Rock itself, drew permanent names that have been passed through the generations. No one knows who named Lovers' Rock, but many people know its name.

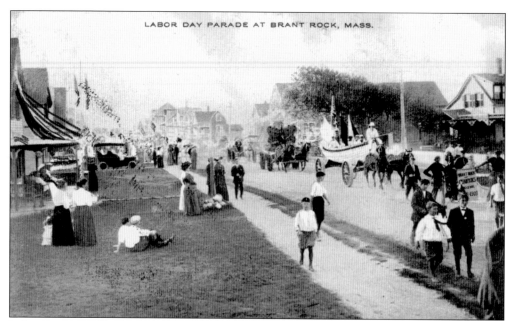

Labor Day started in 1882 as a national day of celebration of the advancement of the economic and social status of the American worker. The local organizations were invited to participate. Here the men of the Brant Rock Life Saving Station, seen atop their lifeboat near the head of the line, proudly join the procession. Today Labor Day symbolizes the end of summer for beach dwellers.

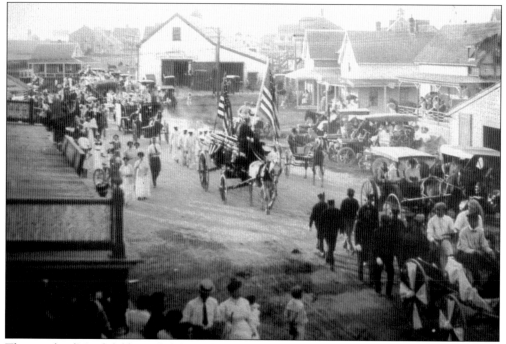

The people of Marshfield paraded through the streets of Brant Rock on many occasions, including the Fourth of July. This undated photograph could have been taken on that date, Labor Day, or perhaps even Memorial Day.

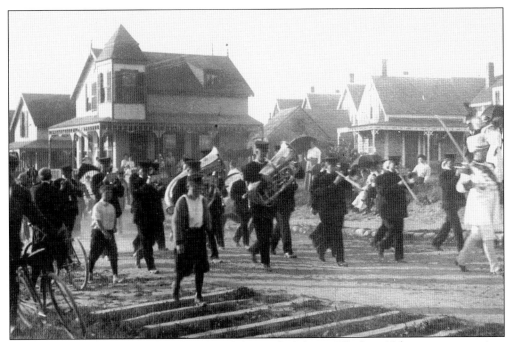

Parades were a time for marching bands and shows of solidarity. The late 19th century was a time of coming together for people of like-mindedness. Improved communication and transportation systems fostered the growth of religious and fraternal organizations. Those organizations—the knights, the sisters, and the grand orders—marched in local parades.

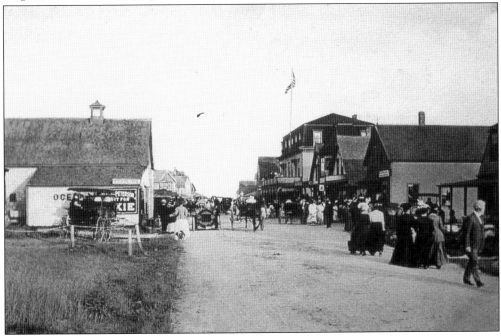

Prior to the widening of the Esplanade in 1927, the south end of Ocean Street was a narrow affair. To facilitate the widening of the street, all of the buildings on the west side of the road were moved back onto the marsh.

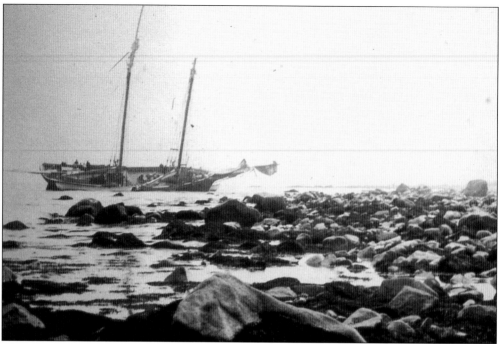

The men of the United States Life Saving Service and the volunteers of the Humane Society of the Commonwealth of Massachusetts were certainly busy during the colder months, when shipping was most susceptible to disruption by the weather. The Mertis H. Perry was one of more than 350 ships tossed around by the Portland Gale of November 26–28, 1898. Wrecked at Rexhame, the Mertis H. Perry claimed five lives.

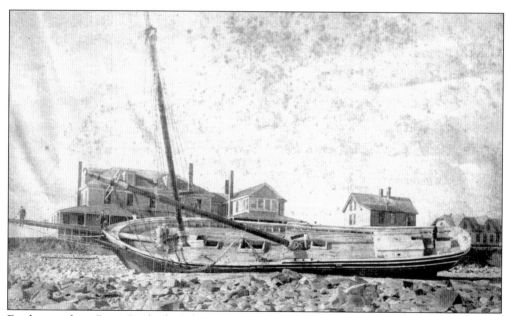

Further south, at Brant Rock, the Edgar S. Foster came ashore in front of Philip's Cottage during the same storm. All along the coast, from New Jersey to Nova Scotia, the winds and waves took more than 500 lives. Lifesavers, both professional and volunteer, rescued 120.

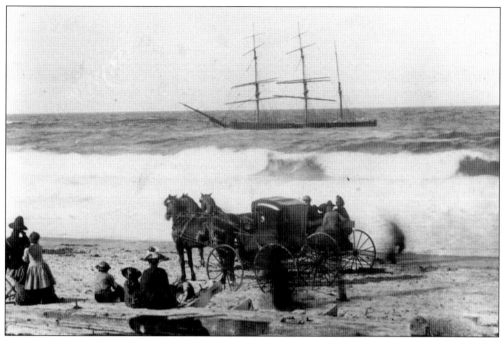

The crew at the Fourth Cliff Life Saving Station on Humarock, then connected to Scituate by means of a barrier beach across what is now the mouth of the North River, rescued the crew of the bark *Chattanooga*, grounded at Hewitt's Point on June 25, 1888.

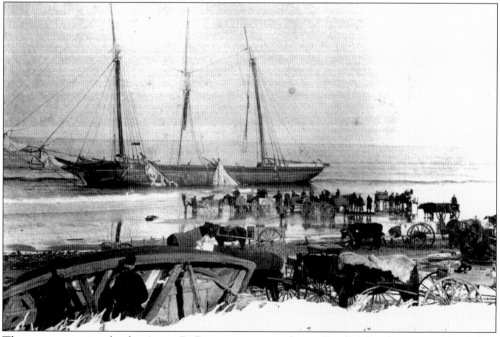

Three years previously, the *Agnes R. Bacon* ran aground near Beadle's Rocks, just south of what was then the mouth of the North River, near Rexhame Beach. The entire crew was rescued by means of a shore-to-ship contraption called the breeches buoy. Beadle's Rocks bear the surname of one of the earliest families in the Rexhame area.

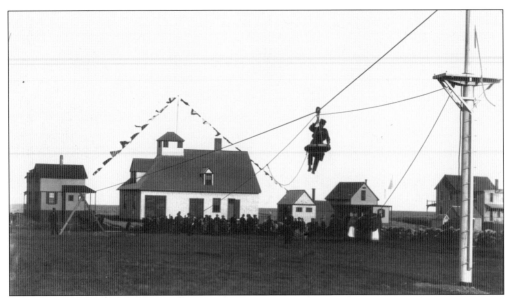

The lifesavers at the federal Brant Rock station practiced twice a week with the breeches buoy system, as required by the regulations of their service. A line-throwing gun tossed a light line to the ship. When that line was secured, the lifesavers ashore affixed a heavy line, a block (pulley), and a wooden board with instructions on it, called a tally board, to the light line. The shipwreck's victims were then instructed to pull the line aboard.

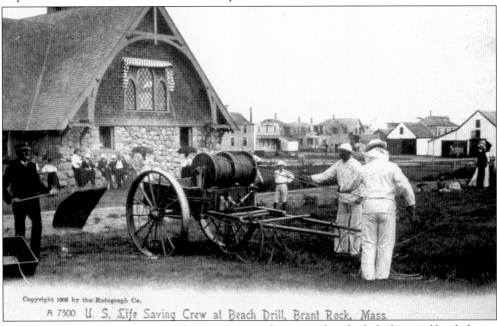

Once that line was aboard, a second wave of materials were tied to the light line and hauled onto the ship, including a third line, called the whip, and the breeches buoy itself, a pair of canvas pants sewn onto a life ring and suspended from a traveling block by means of four ropes. The whip, tied to a ring beneath the traveling block, ran through a pulley ashore and the other one on the ship, before being tied again on the opposite side of the ring beneath the traveling block, creating a complete circle.

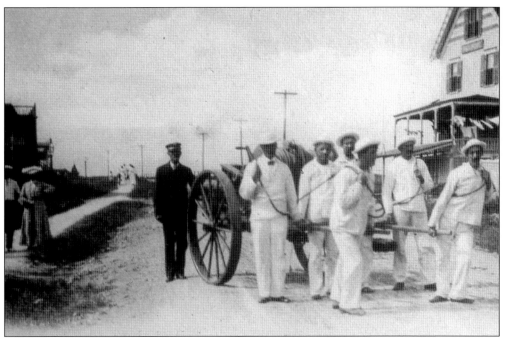

The lifesavers hauled all of the needed materials on the beach apparatus cart to disaster scenes. Some stations owned horses, but those that did not made due by lashing themselves to the cart like sled dogs, and dragging the cart and its lifesaving appurtenances to the shore.

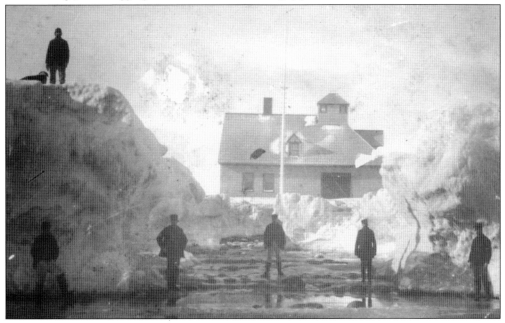

The surfmen of the U.S. Life Saving Service, shown here at Brant Rock in the aftermath of a winter storm, took the summer months of June and July off while their station keeper remained on duty. As pleasure boating increased, the role of the service changed to that of a year-round agency. In 1915, the U.S. Life Saving Service merged with the United States Revenue Cutter Service to form the United States Coast Guard.

One can imagine that when the "blues" started running along the shore in August every year, fishermen would find their favored spots from which to cast. Bluefish Rock and Bluefish Cove bear the name of the only member of the *pomotomidae* family, the sharp-toothed bluefish.

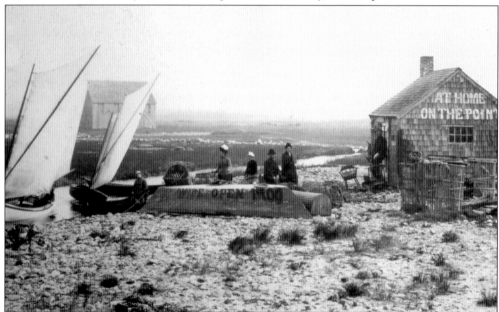

Bluefish Cove, near the mouth of the Green Harbor River, was a sportsman's delight, a place not only to fish, but to hunt as well. Scoter ducks pass along the South Shore in fall migration in massive numbers, as they did in the late 1890s when "coot" gunning (coot is a colloquial name for the three species of scoters) was popular. Long lines of hunters rowed offshore in a line perpendicular to the beach to await the birds' arrival, or found promontories jutting into the sea on which to stand and fire.

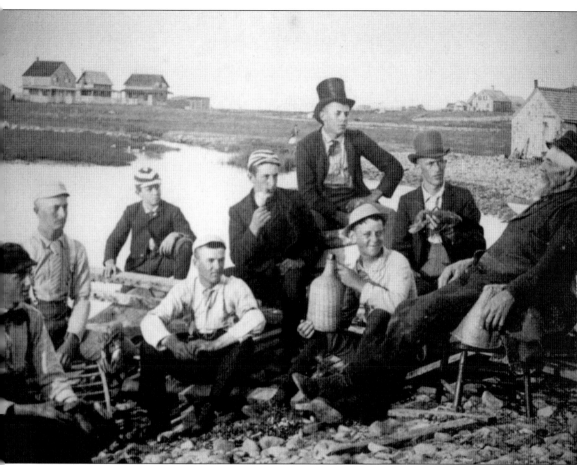

One can only wonder what the old-timer in this photograph taken at Bluefish Cove is telling the young men literally at his knee. Unfortunately this is most likely a posed shot, yet it is one that is certainly descriptive of the times. The late 1800s was a time of discovery and innovation in the field of photography. In places like Brant Rock in the 1880s, one might find a roving camera-wielding entrepreneur offering to take family keepsake photographs on the beach for a price, or one might see a sign posted on a storefront window inviting one and all in for seated formal portraits. Later as the century turned, cameras became household items. Camera manufacturers quickly leapt into the postcard frenzy of the early 20th century by designing photograph paper backed with ready-made postcard address and postage markings. Most importantly, for modern historians, the early photography era has provided a clear window into the past.

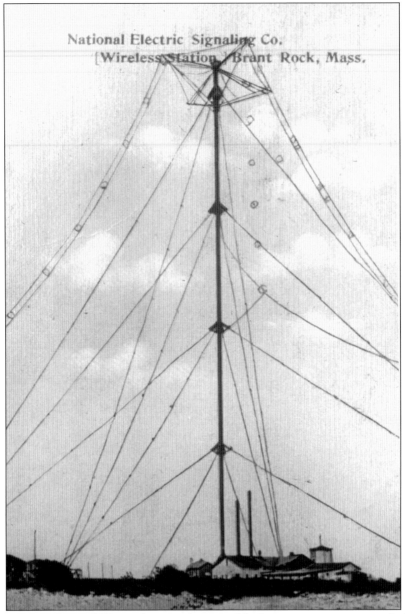

Canadian inventor Reginald Fessenden joined two wealthy businessmen in creating the National Electric Signaling Company in 1902 at Brant Rock for the purpose of designing a system of two-way voice communication over long distances. Already credited with the invention of the liquid barreter, an early radio receiver, while working with the U.S. Weather Bureau, Fessenden had sent his first voice transmission by 1903, with sounds detected as far away as Scotland. Breaking ranks with his partners after squabbles, he formed the Fessenden Wireless Company of Canada in 1906, and later that year completed the experiment for which he will forever be known. That year, on Christmas Eve, he broadcast himself playing "O Holy Night" on the violin and read a prayer that could be heard by forewarned ships at sea, and as far away as Scotland. Although Gugliermo Marconi had sent Morse code broadcasts across the sea several years earlier, no one had yet sent voice and music broadcasts.

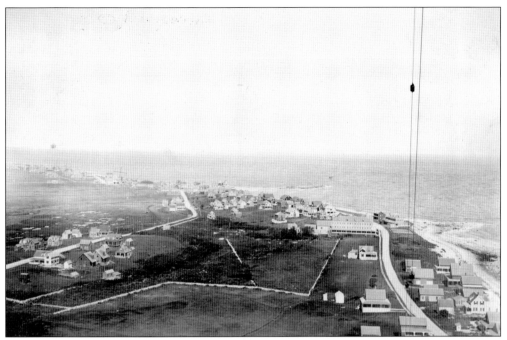

The view from the Fessenden tower in 1906 included a magnificent vista up Ocean Street to Brant Rock in the center of the coastline. It is situated between the ocean and the Green Harbor River and its tributaries. The entire area is known as Branch's Island. Running along the left side of this photograph is Island Street.

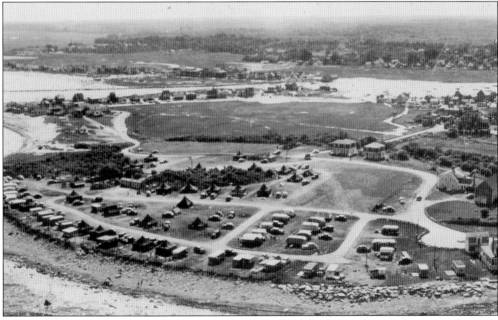

Blackman's Point, at the southeastern end of Branch's Island, has been home to a Humane Society of the Commonwealth of Massachusetts house of refuge, a salt-hay barn, a tenting campground in the 1920s and 1930s, and a trailer park, as shown in this photograph, dated to around 1944.

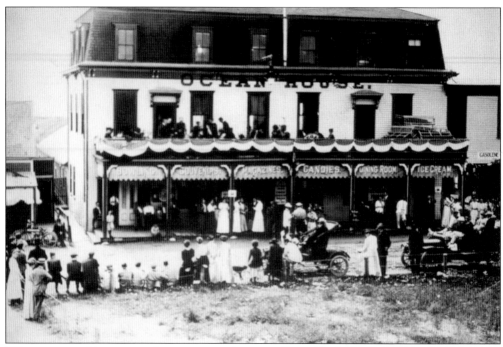

What more could one want from a summer's visit to Brant Rock than a room at an up-to-date hotel? While the signs on the awnings advertised much of what could be seen and done inside, the true joy of the Ocean House was the music from the band concerts that took place on the balcony above.

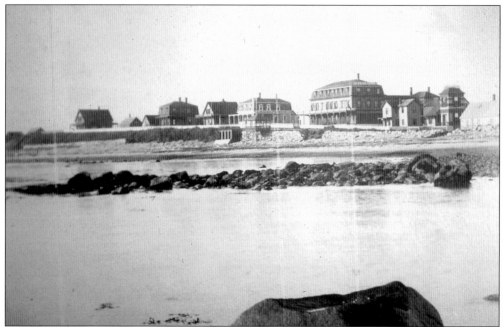

There were high times to be had on the high road at Brant Rock with every summer's day. The Hotel Churchill, in one of its various architectural iterations over the years, is the large building at right.

The Brant Rock House, on the east side of the Esplanade and standing almost atop the geological formation for which it was named, was easily recognizable to both patrons approaching by carriage and sailors passing along the Marshfield coast by boat. Sailors used such prominent buildings ashore as daymarks, navigational aids as important as lighthouses at night.

The Brant Rock House, built in 1874, did not last through the Great Depression before being torn down. The tough economic times of the 1930s compounded the troubles started by the invention of the automobile and the diversion of travelers away from train and steamboat lines. Where once Marshfield was the place to be, Cape Cod and the White Mountains became destinations of choice.

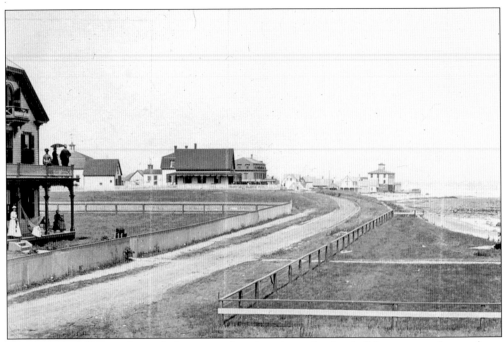

The high road, known for its slight rise in elevation above the level of the water at the southern end of Ocean Street, offered a quick escape from the more concentrated seasonal entertainments at Brant Rock. While Boston was within a few hours travel for the workingman vacationing at the shore, establishments like the Fairview Hotel, at left, were just a few minutes away from the heart of Brant Rock village.

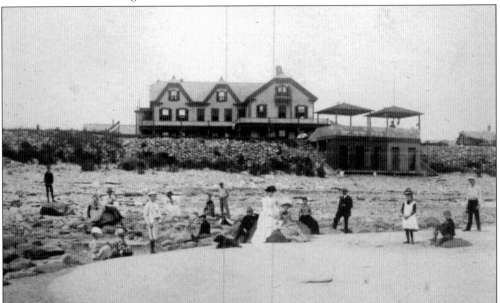

The Fairview Hotel is the last of the Brant Rock hotels standing today, at 133 Ocean Street. Undergoing a dramatic change in ownership and clientele in the 1920s when it was known as the Como Club, the hotel's original name was returned to it in later years. Rumors of a hidden tunnel, possibly used by rumrunners during Prohibition, still float around town today.

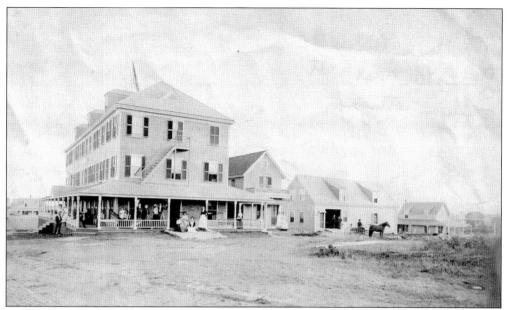

Following Ocean Street south from the Fairview Hotel, one next came to the largest of the Brant Rock hotels, the Peace Haven. While the term "fair view" gave an apt description of what one could gain by a week's stay at that hotel, the name Peace Haven took the notion of relaxation at the shore to an extreme.

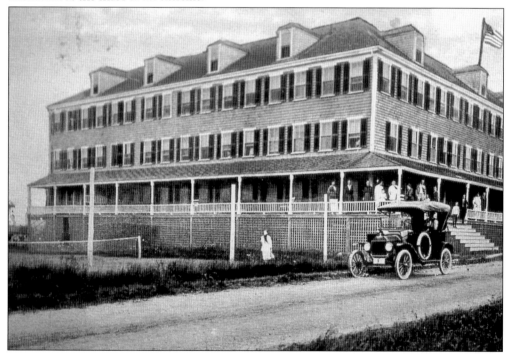

Built in 1903, parts of the Peace Haven exist today in the frames of cottages at Brant Rock and on Hewitt's Island. Also a loss of the Great Depression era, and torn down in a time when lumber was scarce during World War II, the Peace Haven's timbers were recycled to build new houses in the area.

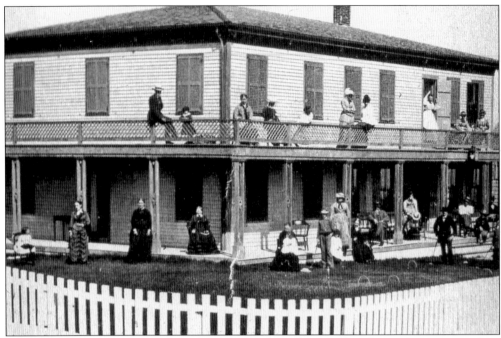

Constructed in 1866, Capt. George Churchill's hotel on what was then Ocean Avenue started out small. In the days after the Civil War, when the industrial age was just beginning and American society had not yet separated into diverse factory owner/worker divisions, summertime pleasures were simple and focused on the regeneration of the body, mind, and soul. This day must have been a cold one, as the shutters are not even open on the building.

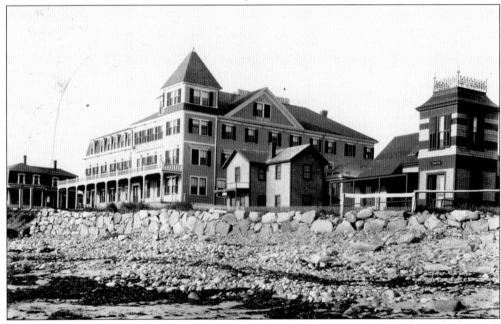

Years later, as Americans began to realize that idle hands did not necessarily always do the work of the devil, as the old axiom went, hotels like the Hotel Churchill expanded to accommodate more visitors and offer more than just a seat on a porch on a sunny day.

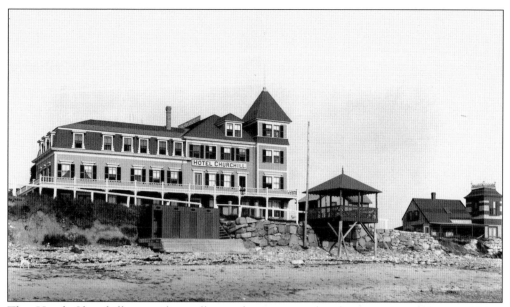

The Hotel Churchill catered to all crowds, even to the distaste of next-door neighbor Dr. Archibald Davison, Sunday croquet players. To stop this phenomenon from occurring, he did the one thing he knew would work best; he bought the hotel. Although quiet in winter, the changing rooms at the base of the seawall saw hectic activity in the summer.

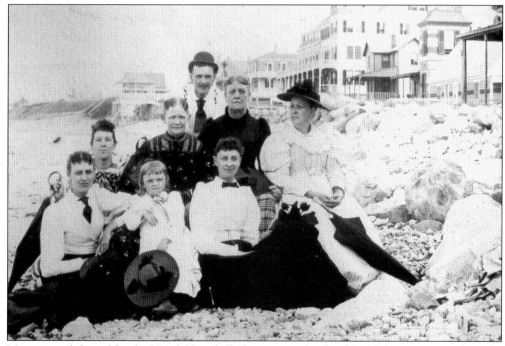

Memories of places like the Hotel Churchill, shown over the shoulder of the woman on the right of this picture, had to be precious for families, like the one shown here. Much sooner than they should have been, those memories became all these folks had, as the hotel burned in 1909.

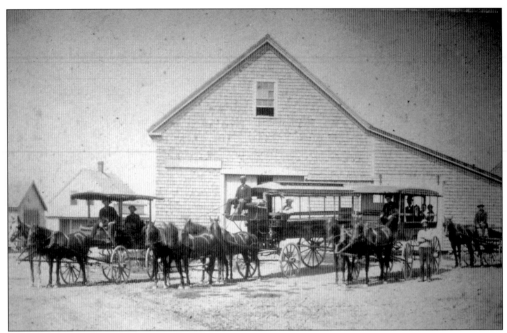

When the time came to move about the village, or, dare one say, leave Brant Rock for the summer, one needed only call on John Flavell at his stable and secure the services of his barge. Barges in coastal towns brought groups on outings to parks or the beach, students to schools, and voters to town meetings. A man with four stout horses and a long carriage could make a goodly sum in Brant Rock before the invention of the automobile.

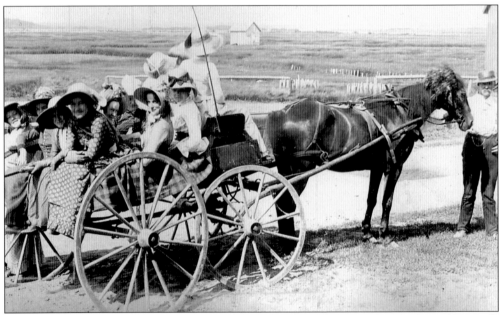

Of course, a man with one horse and a short carriage could do just fine for himself as well. Sometimes folks, like this gathering of sunbonnet-wearing ladies on the low road looking out toward the dyke, needed no particular destination. Just a ride in the countryside was worth the effort of climbing aboard.

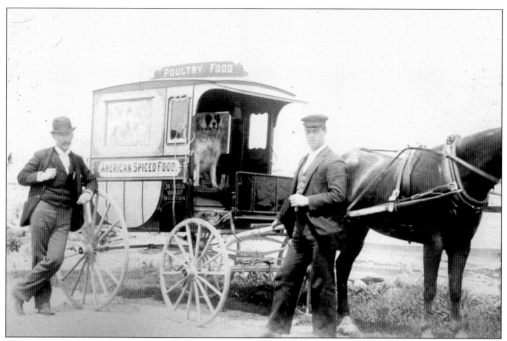

Horses were the engines of the day and are the reason that motor strength today is classified in terms of horsepower. Tax collectors roamed the streets in wagons, as did peddlers and salesmen of all sorts, selling everything from trinkets to the basic necessities of life. Whether spicy foods were a necessity or not one can debate, but these gentlemen were willing to bet there was a market for what they had to sell, even if they had to go door-to-door to move their product.

Andrew T. Magoun operated a tin business and handled his deliveries by himself, although he was restricted in his abilities by the loss of a hand while at work at a mill. No matter what one needed in Brant Rock, it could be found and delivered by the horse and carriage system that had been the tried and true method of transportation in America for more than a century and a half.

When the summer was over and when the Labor Day parade had ended, life would return to normal in Brant Rock. The summer homes would be shut, one by one, with their shutters closed and their porch furniture pulled inside. The local newspapers would announce the diaspora of the summer folk with one-line entries, inevitably announcing that the season had been the "greatest ever known in this vicinity." Dogs and cats left behind would roam the streets looking for food, and eventually, after the last scoter duck had been shot and the last coot stew made and consumed, the hotels would close their doors for the season as well, leaving Brant Rock to its year-round residents. Against their will, for the most part, the children of Brant Rock would return to their district school on the Dyke Road, impatiently awaiting the turn of the calendar year and the prospect for another summer of fun in their treasured village on the Atlantic.

Four
Ocean Bluff, Fieldston, and Rexhame

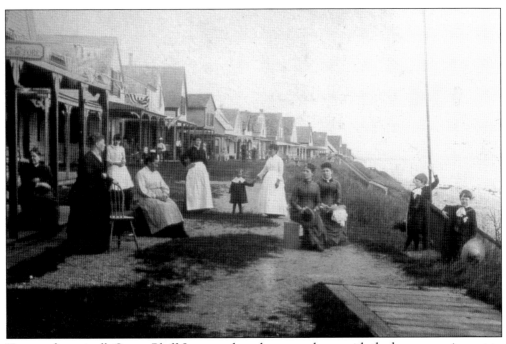

Two words say it all: Ocean Bluff. Just a peek at the scene above, with the houses peering out to where the land drops away to the sea, allows one to see why the Victorians hustled to the shore in spring to secure their rentals for the season along Ocean Street. Here, just outside Capen's Store, a family sports their Sunday best.

The highly congested side streets of Ocean Bluff of today were not even dreamed of—except by real estate dealers envisioning rows of summer cottages—by the average citizen of the 19th century. Here Brant Rock, with the Brant Rock Hotel in the distance across Dyke Road and the Life Saving Station and Union Chapel at top left, gives way to the beginning of the Ocean Bluff village to the north.

Still symbolic of the country's and the town's agrarian past, stonewalls dominated the fields at Ocean Bluff, making for an incongruous juxtaposition of the bucolic and the potentially honky-tonk in this photograph. Just steps away from grazing cattle, thrill seekers gravitate to the beach, the ballroom, and the pool hall.

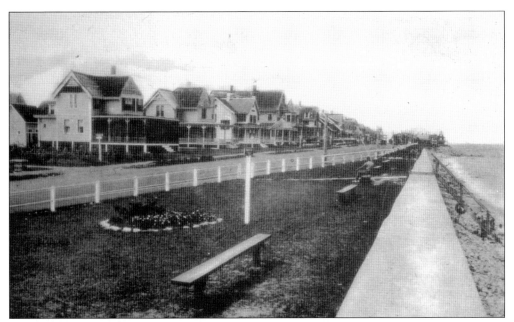

Prior to the 1950s repairs of the sea wall along Ocean Bluff, the town boasted a beautiful seaside promenade in Fairbanks Park. Unfortunately as part of the sea wall reconstruction, the park was paved over as a way of widening the road.

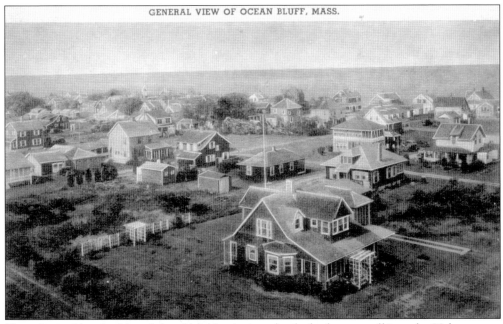

House lots sold and sold, and the old fields continued to be broken up well into the 20th century. The proximity of the houses, while not nearly as tight as many other towns along the coast, would lead to the tragic fire of 1941. So many residents of the inland town of Abington sought summer relief at Ocean Bluff that the area bore the unofficial title Abington Village.

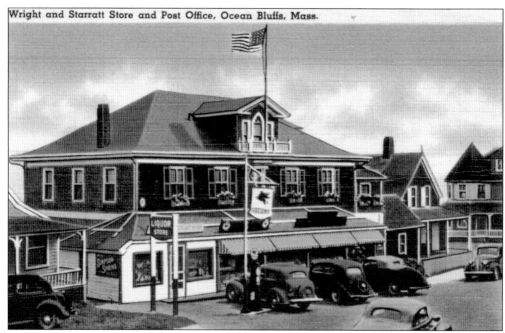

Provisions for any summer jaunt could be purchased from the store of Bessie Wright and Gordon Starrett, formerly owned and operated by the firm of Briggs and Maxwell (which also at one time owned the Capen store on the bluff). Such stores also usually housed local post offices. Both Wright and Starrett were postmasters for the Ocean Bluff Post Office.

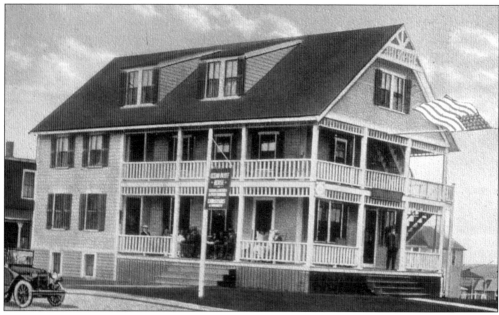

The Ocean Bluff House, just south of St. Ann's-by-the-Sea Church on Ocean Street, with its wrap-around verandahs and gothic, stick-style architectural traits, not to mention its symbolically patriotic American flag, made for a striking advertisement in this postcard. Add in the automobile to the left, and the view offers modernity, with respect paid to the past, patriotism, and all the comforts of home with easy access to the beach.

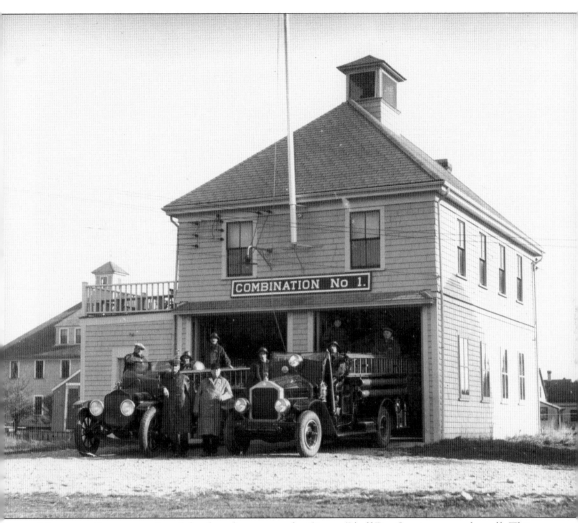

Like many fire companies of the day, the crew at the Ocean Bluff Fire Station started small. This fire station has been on Massasoit Avenue since the early days of the 20th century. And while every station and every department has a story to tell about the biggest blaze its men, and now women, ever had to battle, no department on the South Shore of Boston can claim to have faced a blaze on their own turf like the conflagration that struck the Ocean Bluff area at 1:40 p.m. on Monday, April 21, 1941. It all started with a small, brief, and seemingly controllable fire on the corner of Plymouth Avenue and Ocean Street, until the prevailing 30-mile-per-hour winds upped the ante.

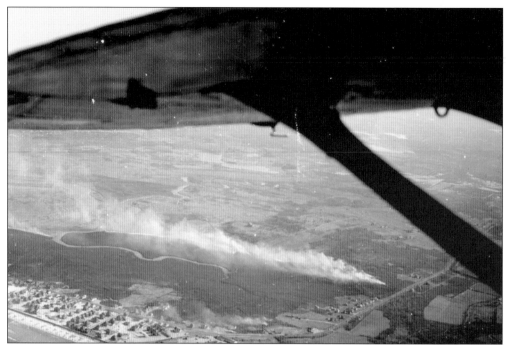

Smoke climbed into the sky until it became visible at the north end of Cape Cod, at Provincetown, and as far to the south as Nantucket Island. Fire companies from the surrounding area roused themselves into action and headed for the scene as the fire spread across the grasses left brittle by an unseasonable stretch of dry weather.

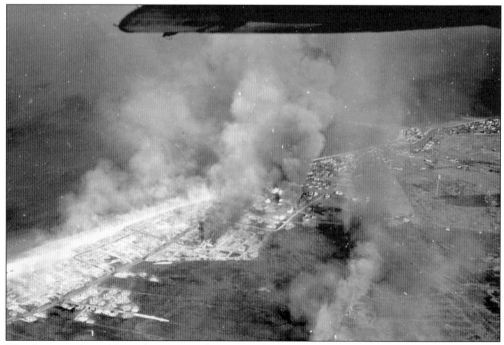

The fire spread quickly, indiscriminately igniting house after house. Cars burned, as did hotels. Even the fire trucks themselves became victims to the inferno they fought to control.

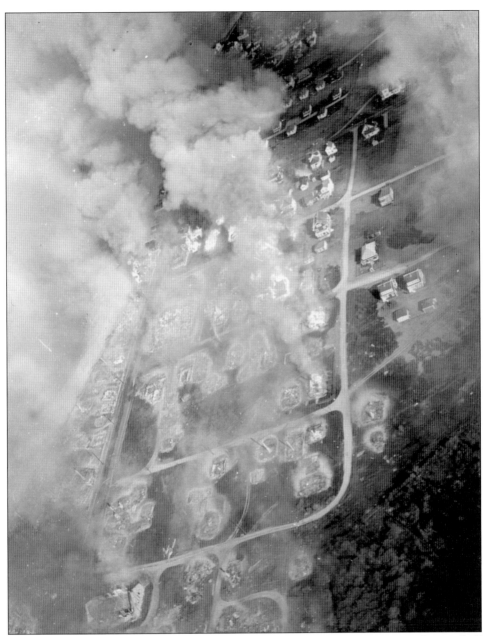

With the wind at its back, the blaze marched unabated to Samoset Street in the south. For four hours, the flames leapt skyward, shattering the seaside dreams of hundreds of summer residents. With the setting of the sun came the crucial abatement of the winds. At 5:30 p.m., the firefighters, many of them volunteers, wrestled the flames into submission, but the damage had been done. What was once known as Abington Village no longer existed; where once summer carousers walked gaily and carefree through the streets now lay the remains of an entire Marshfield village. "The devastation was total," state Cynthia Hagar Krusell and Betty Magoun Bates, authors of *Marshfield: A Town of Villages*. "Two hotels, the post office, the Casino, the church, twelve stores, 446 houses and cottages, and 96 garages." Ocean Bluff, as thousands had known it, was no more.

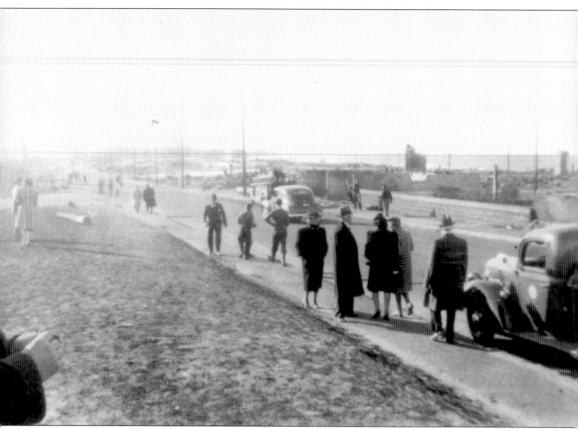

In the days that followed, summer residents, many of them from Abington, came to sift through the ruins, to see if anything was salvageable. Instead they found a wasteland. They could, though, pull two unbelievable bright spots out of the otherwise all-pervading gloom. First, while 30 residents were left homeless by the firestorm, not a single life had been lost, mostly due to the fact that the summer crowd had not yet arrived for the season. Second, state Cynthia Hagar Krusell and Betty Magoun Bates, while "burned hoses and fire engines littered the streets . . . The Ocean Bluff fire station on Massassoit Avenue, however, survived the fire."

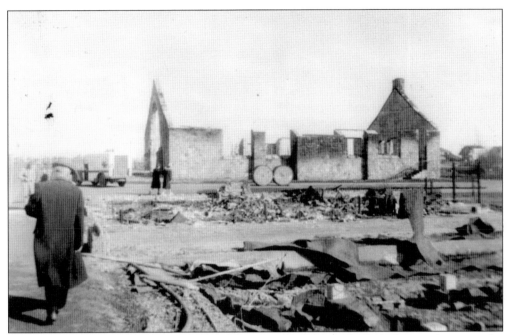

St. Ann's-by-the-Sea Church, symbolic of the growth of the Irish Catholic population in the village, withstood the worst the fire had to offer, ultimately losing everything but its walls. Yet the fire did not cause the parish to shut down, by any means; the current St. Ann's-by-the-Sea was constructed in 1957.

In fact, in an act of pure faith, the Town of Marshfield moved quickly to rebuild Ocean Bluff. In 1941, the United States was still mired in the last days of the Great Depression, and in April, stood just more than half a year away from entry into the World War II. The fire, in the end, put many Marshfield residents back to work, cleaning up the wreckage and building new streets.

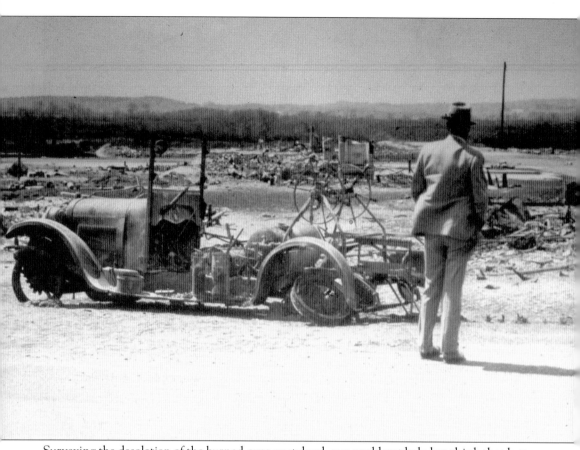

Surveying the desolation of the burned-over wasteland, one could not help but think that better days had to be ahead for Ocean Bluff.

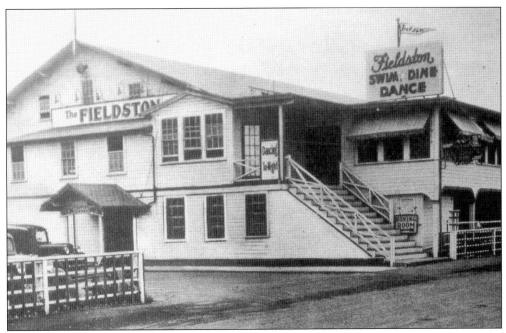

Just to the east of the starting point of the Ocean Bluff fire sat Fieldston-on-the-Atlantic, the symbol of summer fun in the village of Rexhame. Built in 1925, it became a South Shore hot spot that boasted talented musicians and band leaders from Count Basie, to Guy Lombardo, to Harry James. But more than just a music hall, the Fieldston-on-the-Atlantic complex featured a myriad of ways to have fun.

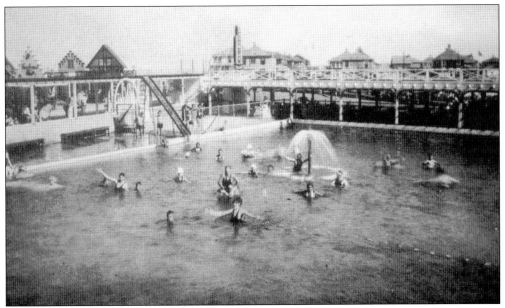

Quincy ice cream entrepreneur Howard Johnson set up a stand at Fieldston-on-the-Atlantic, knowing a good opportunity when he saw one. One could play miniature golf, swing a baseball bat, or even take a dip in the pool. In later years, after a succession of owners, it became known as the Rexicana, before falling into disrepair and eventual dismantling.

Rexhame grew out of the area known as Marshfield Neck, between the South and Green Harbor Rivers to the top of Rexhame Hill. As late as the 1930s, five of the original farms remained active on this fertile land. Development had touched the region in the form of Rexhame Terrace, and joviality and fun had joined it at Fieldston-on-the-Atlantic.

In 1875, the first homes of Rexhame Terrace arose from the soil, bringing croquet players, among others, to the seaside spot. The 1960s and the coming of the Southeast Expressway brought great upheaval to Rexhame, through increased population and expansion of business and housing interests along Ocean Street. Yet for decades, if one wanted to find frivolity with a touch of class at the seashore, one needed only to look along this stretch of beach from Rexhame to Green Harbor.

Five

WHERE THE SOUTH RIVER FLOWS

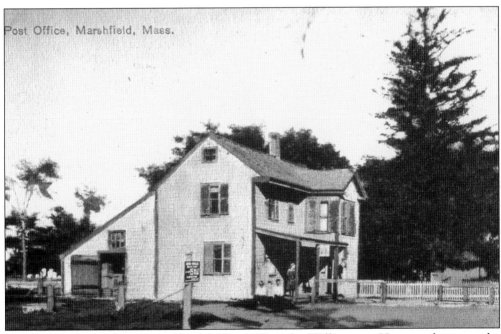

The first settler in downtown Marshfield was Timothy Williamson. He gave the town the Training Green and land for the First Church of Marshfield. His tavern, or ordinary for "lodging and victualling," was licensed in 1673. In 1773, when it was known as Bourne's Ordinary, it was the site of the American Revolution–era Marshfield Tea Party. Patriots stole tea from this store and burned it on nearby Tea Rock Hill.

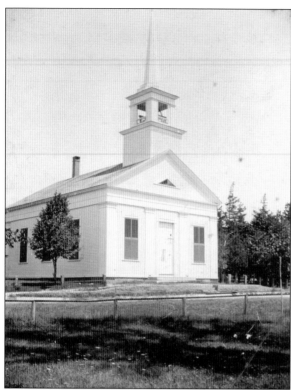

The First Church of Marshfield was the second church to break away from the original Pilgrim church at Plymouth. The present church was built in 1838. The fourth church building on this site, it is still a Congregational church. With its sweeping view of the old Training Green and the present town hall, it marks the spiritual and political center of the town.

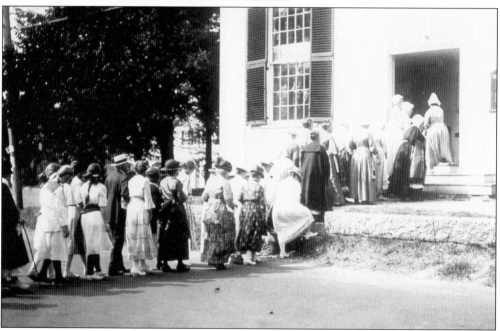

The church and the town were the same for the first 100 years. Town meetings were held and town records kept in an early church, located at what is now Winslow Cemetery. For a town founded by Pilgrim settlers, it was appropriate that the people seen here were gathering at the First Church of Marshfield for the 1920 anniversary of the landing of the Pilgrims.

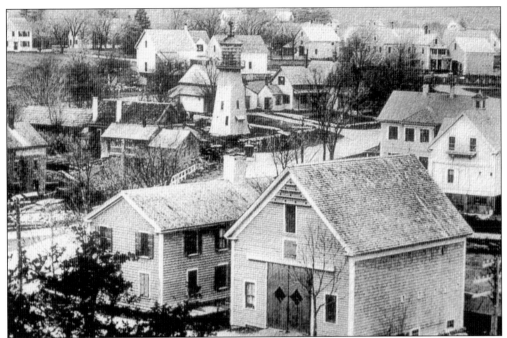

Here one sees a bird's-eye view of the 1656 Ford gristmill, the first mill site in town. Now the Veterans' Memorial Park, it was for many years the center of commercial Marshfield. Here has been a long progression of milling and manufacturing operations, from sawmills to cotton mills and a laundry. Nearby David Brown ran a blacksmith shop.

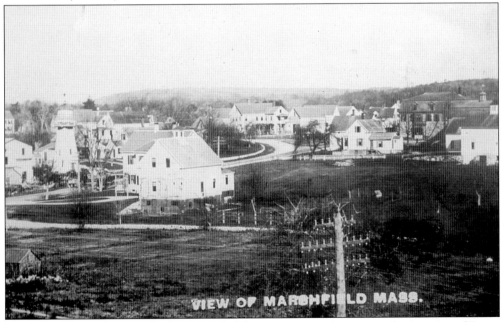

The road running through the foreground of this picture is at the present-day junction of Route 139 and Route 3A at the Veterans' Memorial Park. The windmill was used to pump water from the South River. In the distant right can be seen what for many years was Reed's Ark and before that the Marshfield Company Store, and then an Atlantic and Pacific store (A&P).

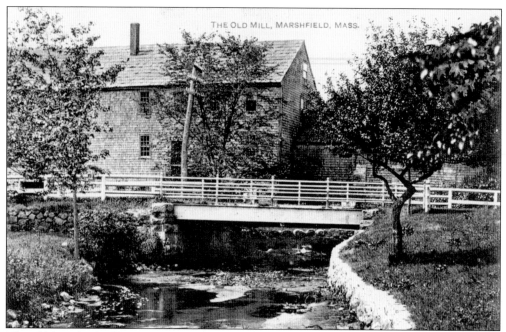

The old laundry building known as the "wet wash" was a familiar sight during the 1930s and 1940s. After being abandoned, it was taken down in 1948 when the Veterans' Memorial Park was created. In the 1950s and 1960s, nearby well-known businesses were Hubbard's Cupboard and a series of garages; today there is the Lord Randall Bookshop and the South River Motel.

Here in place of this rapidly deteriorating old laundry building now stands the scenic Veterans' Memorial Park. Today many people choose this site for their weddings and celebratory gatherings. The rushing waters of the South River turning the water wheel bring memories of days when the mills here produced grain, lumber, and cotton sailcloth for the shipbuilding industry.

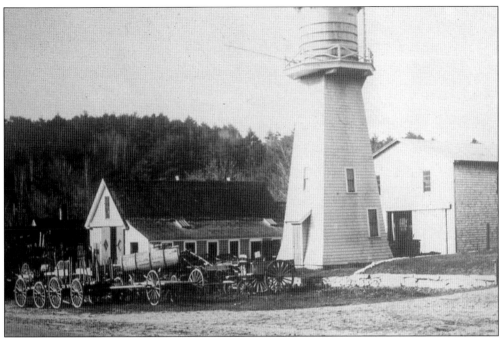

Near the site of David Brown's blacksmith shop there was also a wheelwright shop owned by Charles Tilden Hatch. In 1855, he purchased the Concord Coach that was used to run the old route to Hingham. Fittingly in subsequent years, several different automobile supply shops, repair shops, and garages have been located here.

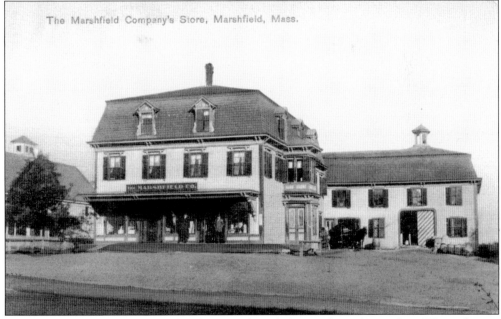

This building was known far and wide as Reed's Ark during the 1950s to the 1970s, a place to pick up almost anything one might need. It was built about 1879 by Luther Hatch and was first called the Marshfield Company Store, a grocery store. Later it became an A&P. Today it is the Safe Harbor Church.

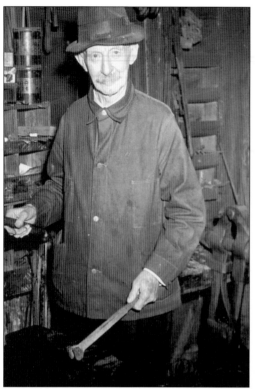

No one in Marshfield today remembers David Brown, the blacksmith. But there are few who do not recognize the name of his daughter, Grace E. Ryder. She taught in the Marshfield schools for many years. Those who were her students were not likely to forget her. A school was named in her honor and is today the Grace E. Ryder Housing Complex across from the fairgrounds.

In the horse-and-buggy era, the place to have your carriage wheels fixed or your iron fittings made was David Brown's blacksmith shop. It was the busy social center of that time, as was Hubbard's Cupboard in a more recent period. Today Matt's Auto (operated by Matthew Whalen) is located in this same place and serves similar needs.

Old Ferry Street led north up Tolman's Hill and continued through Center Marshfield to the North River ferry crossing at Humarock. When the Methodist church arrived in 1825, the hill quickly became known as Zion's Hill. The church was founded by a small group of people including the Tolman, Williamson, and Chandler families.

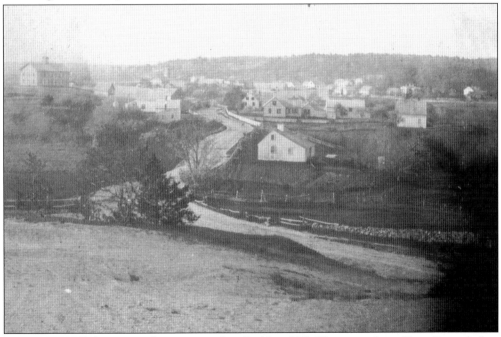

From Zion's Hill there was a fine view south to Pudding Hill. This view shows Ferry Street before the building of Main Street, now Route 3A. At the bend in the old road, there is located today a preschool called Cherubs. In former years it was the site of the Marshfield Inn and later Casa Berrini's restaurant. Note the old Marshfield Fair building far to the left.

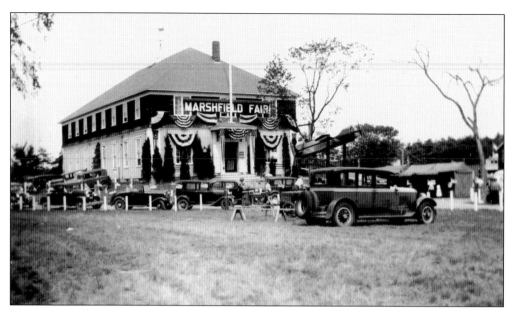

The Marshfield Fair was established in 1862 by the South Marshfield Farmer's Club. Later called the Fairgrounds Association, it was incorporated as the Marshfield Agricultural and Horticultural Society in 1867. The inspiration for an agricultural fair in this area came from Daniel Webster, who would be pleased to see how famous the fair is today.

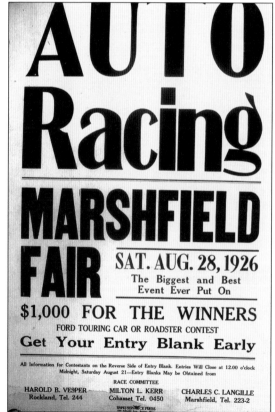

Automobile racing was the popular event in 1926 with a Ford touring car and roadster contest. The grandstand was erected in 1900, and the half-mile racetrack was designed by the famous financier Thomas Lawson, fair president from 1905 to 1910. Later pari-mutuel horse racing became a favorite event along with the amusement rides and 4-H Club livestock exhibits.

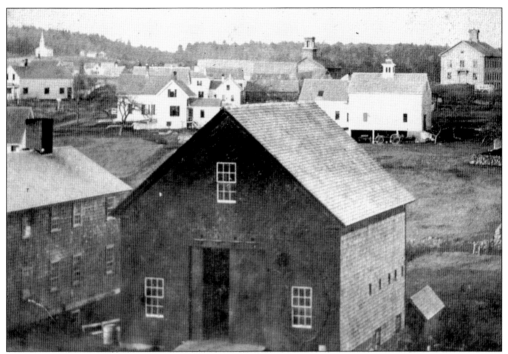

This array of interesting buildings can no longer be seen today. To the far left is the old Methodist church on Zion's Hill. In the middle distance is the 1858 Wesleyan Chapel on South River Street across from today's Central Fire Station. Far to the right is the old Marshfield Fair exhibition hall built in 1872 by John Baker and replaced with the present hall in 1898.

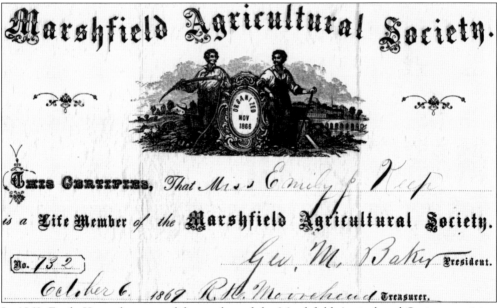

In 1869, Emily Keene became a life member of the Marshfield Agricultural Society receiving this certificate from the first fair president, George M. Baker. Recent presidents have included Ernest Sparrell, Charles Langille, Frank L. Sinnott, Edward Dwyer, Eben Briggs, Frank Melville Sinnott, Russell Chandler, Jerry Kroupa, and today's president, Leonard La Forest.

Still known to many as the "old South School," this building was erected in 1857. It served as the south grammar school for many years. In 1940, there was a major reassignment of town buildings. The South School building became the Ventress Library and the school children were moved to the "Alamo" on Hatch Street. The South School building has recently been the Hancock Paint Store.

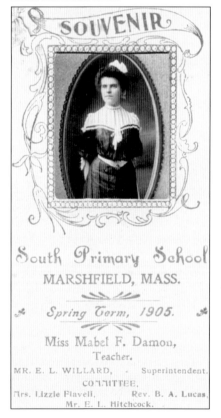

Children attending the South School in the early 1900s received souvenirs upon their graduation. This memento shows a picture of the teacher Mabel F. Damon and also lists the superintendent and school committee members. Another card lists the pupils in the four grades, 10 in each grade for a total of 40 students in two rooms.

In 1884, Seth Ventress left a legacy to the town "for a public library." With this gift, the Ventress building on South River Street was built and dedicated in 1895. It has been used as a library, town hall, school, police department with lockup, and school administration building. The original library collection was moved to the South School and, in 1984, to its present site at Library Plaza.

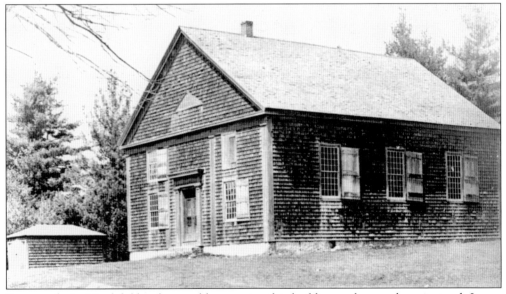

Few people in Marshfield today would recognize this building or know where it stood. It was once the town hall with a hearse house nearby. Daniel Webster spoke and voted here. From 1838 to 1895, town affairs and meetings were conducted in this hall which stood near today's Carolina Hill Respite Center. From 1895 to 1971, the town hall business was carried on in the Ventress building on South River Street.

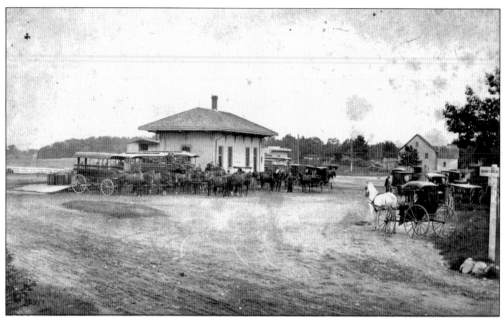

The downtown Marshfield railroad station was located where the skate park on Webster Street is today. The Old Colony Railroad line was extended to Marshfield in 1870. The horse-drawn barges seen here transported visitors to the beach resorts at Brant Rock. Local people pulled up to the station with their horses and carriages to catch the next train to Kingston or Boston.

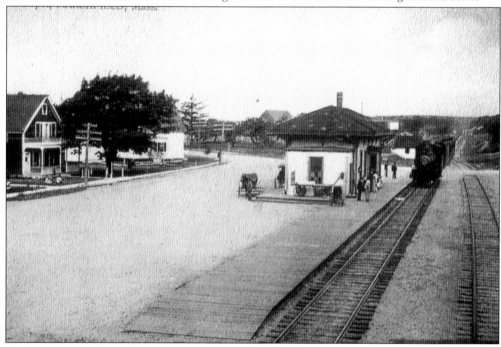

The Marshfield railroad station at Ocean and Webster Streets was one of five train stations in the town. The train seen here heading south has stopped at Marshfield Hills, Seaview, and Center Marshfield and would be on its way to the Green Harbor station, Duxbury, and Kingston. The last train over these tracks ran on June 24, 1939.

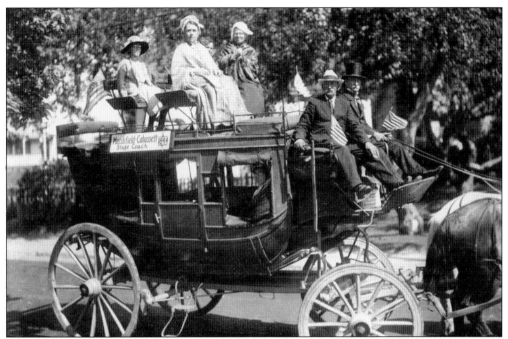

The Marshfield-Cohasset Stage Coach was purchased by Charles Tilden Hatch in 1855. He lived near the intersection of Route 3A and Old Plain Street and owned the nearby wheelwright shop. For many years, Hatch ran the coach route to Hingham, where passengers could catch the boat to Boston.

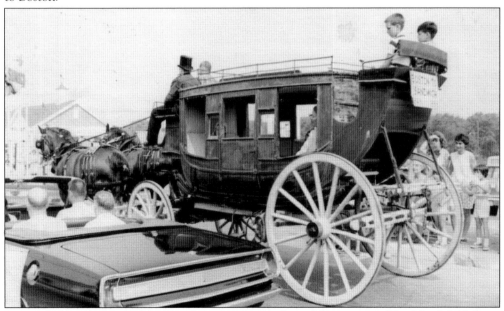

Here side by side are two means of transportation from different eras. The Marshfield Stage Coach was later purchased by the town and kept at the Marshfield fairgrounds for many years. In the 1980s, it was moved to a new carriage shed on the grounds of the Isaac Winslow House where it can be viewed by the public. It is maintained by the Marshfield Historical Commission and taken on the road once a year to keep it in good running condition.

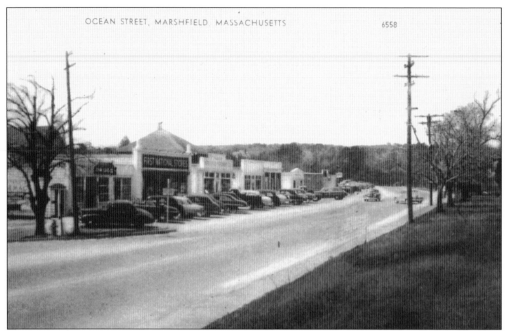

Seen here is Ocean Street at Webster Street as it looked about 1940. The tallest building is the old First National grocery store. This row of stores has now been superseded by the Curtis complex of buildings on Snow Road. Current plans call for a complete renovation of the buildings and area seen here.

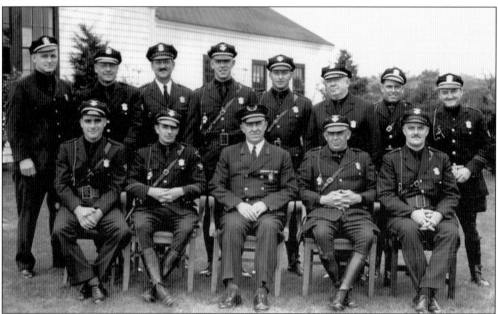

This is the Marshfield police department in 1938 at the old Marshfield Police Station at Dyke Road and Marshall Avenue, Brant Rock. Seen here are, from left to right, (first row) Harold Whitcher, Charles Simmons, Chief William Pratt, Cliff Valier, and Harold Roberts; (second row) Louis Handy, George Ford, Fred Walthers, Dick Melvin, Harold Ford, Jack Ganley, Clyde Gates, and Beanie Colomore.

Six

WITH A VIEW OF THE SEA

Peregrine White, first born child of the Pilgrims at Plymouth, came to Marshfield in the 1630s as the stepchild of Gov. Edward Winslow. White married Sarah Bassett and built his home overlooking the old mouth of the North and South Rivers, with a view of the sea. He was a farmer, surveyor, and representative to the general court. In his 70s, he became a schoolteacher and joined the First Church of Marshfield.

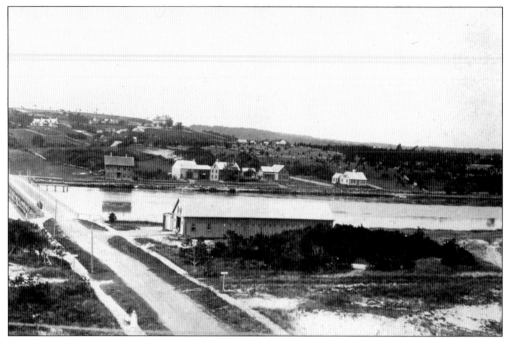

Here from the South River at Humarock can be seen Holly Hill as it looked about 1895. Along the river banks are the old houses of the White family who ran White's Ferry shipyard located near the present Humarock Bridge. At the top of the hill is the Gov. George W. Emery estate. Emery, who owned most of Holly Hill, was governor, not of Massachusetts, but of far-off Utah.

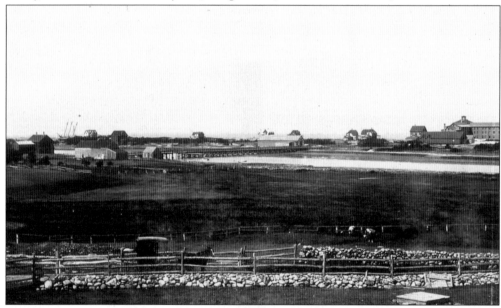

Here is a view of Humarock taken from Elm Street in Marshfield. In the foreground are the old stonewalls lining Elm Street with a horse and wagon wending its way toward Ferry Street. In the distant right is the old Hotel Humarock, built about 1895 and destroyed in 1909. Far to the left in the distance can be seen the masts of the schooner *Helena*. She went aground on January 31, 1909, and her timbers were used to build many of the houses on the beach.

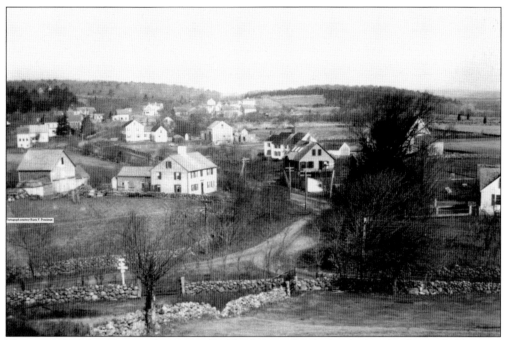

The village of Sea View at first was called Littletown for the Little family who settled here in the 1650s. Taken about 1900, this view shows Summer Street from the foot of Holly Hill at Elm Street. The large, white square colonial house was home to the Hatches for many generations. Charles Hatch came here after his marriage to Joanna Winslow in 1787. In the center to the right is Randall's Mill and the Little family homestead.

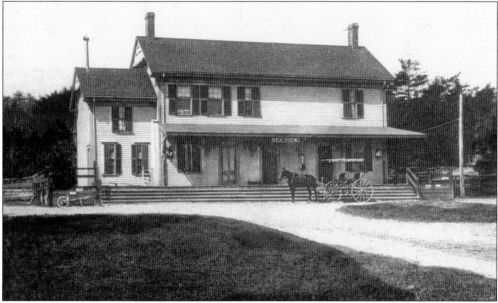

Visitors vacationing at the Hotel Humarock or at beach cottages around the 1900s would arrive by train at the Sea View railroad station, the largest station on the Old Colony line. Here they were met by horse and buggy and transported to the beach area. The railroad track was removed in 1939, and the old railroad bed is now used as a foot-and-bridle path.

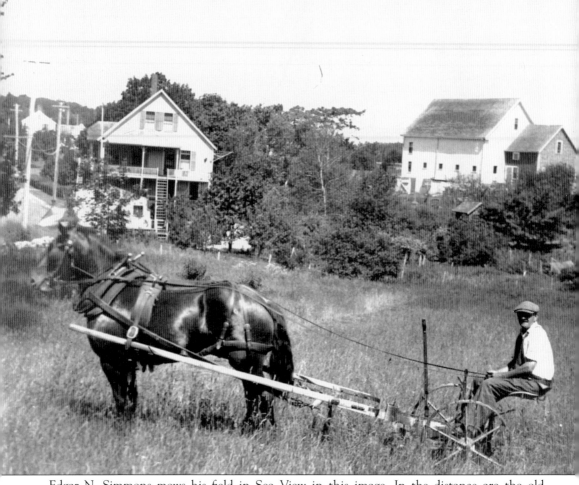

Edgar N. Simmons mows his field in Sea View in this image. In the distance are the old Randall Mill and the Luther Little farm. At the mill site on Little's Creek, later called Keene's Pond, the Littles operated a gristmill as early as 1838. In 1871, William and George Randall purchased the mill and made organ parts and violin cases. The shop burned in 1884 but was rebuilt and continued to operate until 1903. Later A. Lincoln Creed did woodworking here until the 1940s. The building burned in 1960. Seven generations of the Little family lived in Sea View. Most famous were the brothers Luther and George Little, patriot naval heroes of the American Revolution. They were on the ill-fated naval Penobscot Expedition of July 1779, when the Americans were forced to burn their own ships and retreat. Luther and George went on to fight a number of successful naval battles. They frequently made merchant voyages to the West Indies for sugar and molasses, and Luther undertook six adventurous merchant trips to the Gulf of Finland, Estonia, and Russia.

This image depicts Marshfield Hills, the northeastern part of Marshfield bordered by the North River. The river's present outlet to the sea between Scituate's Third and Fourth Cliffs was created by the November storm of 1898. The old mouth, located three miles south at Rexhame, closed in with sand bars. In Marshfield Hills village, one can hear the roar of the sea off Fourth Cliff and Humarock and see the tides rise and fall over the marshes at Trouants Island and Macomber Ridge. At the intersection of Old Main Street and Pleasant Street, shown above, the homes of Calvin and John Damon can be seen, built in the 1820s. Their federal style of architecture is typical of this upper part of the village built largely in the early 19th century. The first settlers to this part of Marshfield built their homes down along Summer Street on the flat land easily accessible by the river and marsh creeks.

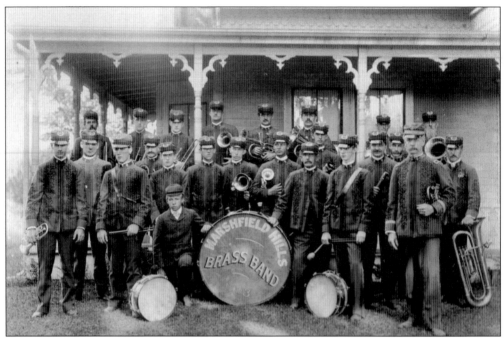

Marshfield Hills has always been a spirited part of the town, proud of its past and present. This Marshfield Hills brass band of around 1900 was composed of members of the old original families of the village and probably included Damons, Rogerses, Ewells, Phillipses, Fords, Halls, Eames, Trouants, and Macombers among its members. They kept things lively in the village.

The current post office building at Prospect Street and Old Main Street has long been the civic center of Marshfield Hills. It was built about 1854 by Elisha Hall who had operated an earlier store across the street with George Weatherbee Jr. Civil War government uniforms and West Indies merchandise were sold here. It has served as a post office since the 1920s, was a Civil Defense Center during the 1940s, and has seen a variety of other uses.

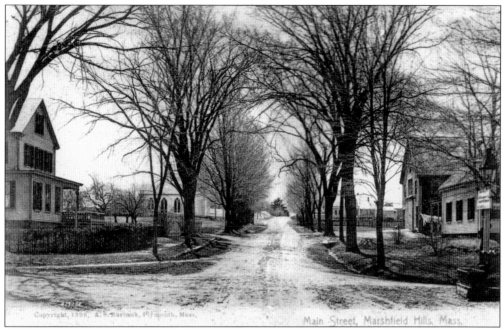

This view looks south up Old Main Street hill toward the churches. Before the construction of Route 3A in 1927, which bypassed the village, this road was the "country way" to Scituate. To the left in the distance can be seen the present North Community Church. Built in 1837 by the Second Trinitarian Congregational Society, it became a Community Church in 1928. To the far right is the Avery Rogers House built about 1855.

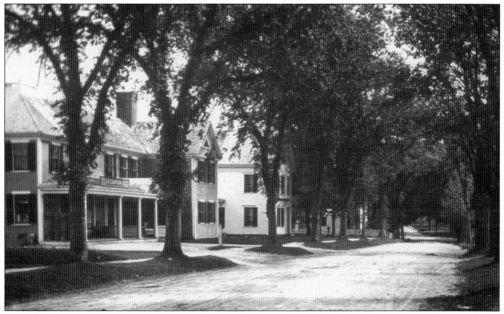

A cathedral of elms once graced the village of Marshfield Hills. Planted in the late 19th century, they were decimated by the 1938 hurricane and Dutch elm disease. Shown here is the Benjamin Simmons Jr. house built about 1819. In the early 1900s, it was the Henry I. Carver Store. Carver sold high-quality groceries that were delivered by horse-drawn cart for many years.

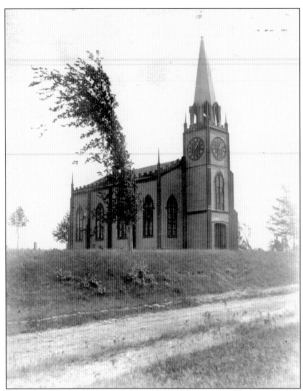

After nearly 100 years of attending the First Church of Marshfield, the people of Marshfield Hills formed their own church in 1738. Called the Second Trinitarian Congregational Church, this church was also known as the Church at the Three Pines or the Chapel of Ease. After a vote in 1835 that retained the church for the Unitarians, the Trinitarian Congregationalists built what is now the Community Church.

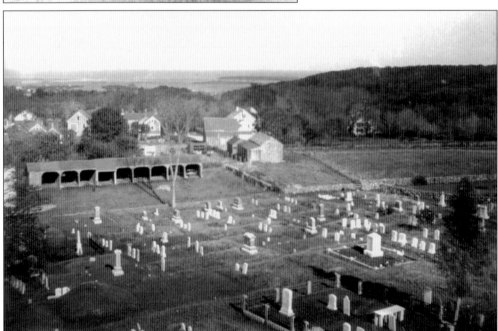

Behold the view from the belfry of the Chapel of Ease, known to later generations as the old Unitarian church. It had a Paul Revere bell and an Aaron Willard clock. The church had three long-term ministers, Atherton Wales, Elijah Leonard, and his son George Leonard. Here can be seen the old carriage shed of the Trinitarian Church, now the North Community Church.

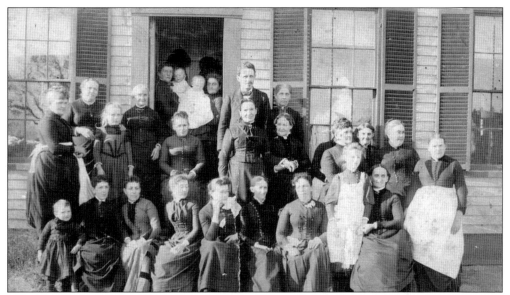

To the women of 1900, like the ladies of the Unitarian Church sewing circle, the church was their social center and an important aspect of their lives. Women served as educators in their role as Sunday School teachers and raised funds through various church fairs and socials. The church congregations were largely composed of women.

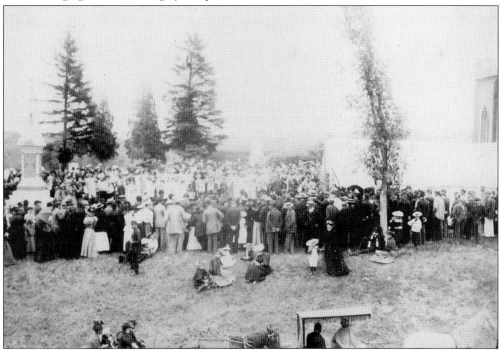

The dedication of the Civil War monument in the Marshfield Hills cemetery brought out a huge crowd of celebrants. They arrived from all over Marshfield in their horse-drawn carriages. It was a day's outing with food and entertainment for all. Today this same site witnesses a similar gathering on Memorial Day with a parade and speeches made here in honor of those who died for their country.

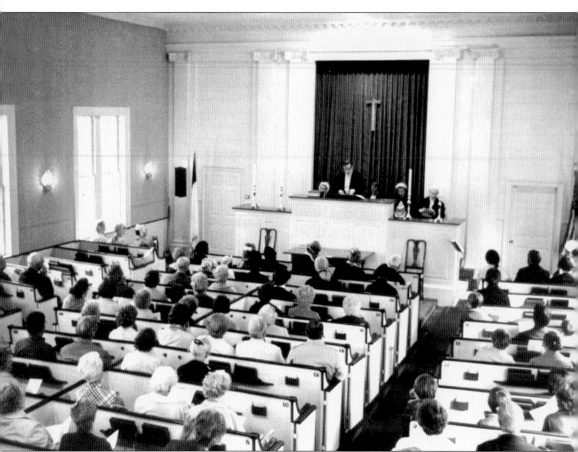

Here in the sanctuary of the present-day North Community Church, formerly the Trinitarian Congregational Church, an unusual event occurred in October 1972. The Marshfield Historical Society staged a reenactment of an 18th century service that would have been held at the old Unitarian church or Chapel of Ease. Here are the parishioners who attended the reenactment, and some of the cast of characters can be seen at the pulpit. The script for the presentation was written by Hope Poor and Rosemary Martinez, who also narrated the service. The players and the parishioners dressed in appropriate clothing for the era. The roles of the early ministers were played by David Williams (Rev. Atherton Wales), Rev. Mahlon Gilbert (Rev. Elijah Leonard), and Richard Martinez (Rev. George Leonard). Hymns of the period were sung including the "Old Hundredth," the "York Tune," and the "Winsor Tune."

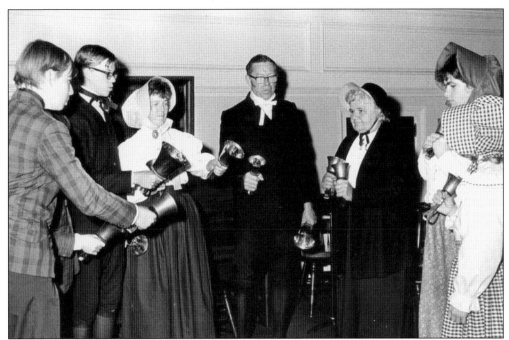

A popular part of the Chapel of Ease reenactment was the bell ringing done by Elizabeth Bradford and her famous bell-ringing group. Seen here intent upon their music are dome members of the group with their leader Elizabeth Bradford, fifth from the left.

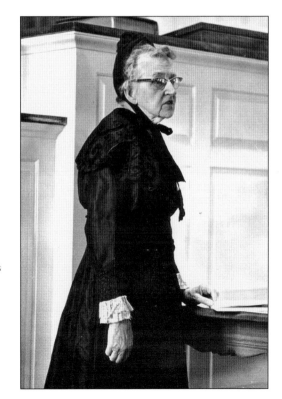

Pearl W. Whittaker, one of the parishioners at the reenactment and president of the Marshfield Historical Society at the time, said a few words at the commencement of the service. She was an inspiration and a guiding light during the reactivation of the Marshfield Historical Society in the 1970s and the subsequent restoration of the old Winslow schoolhouse.

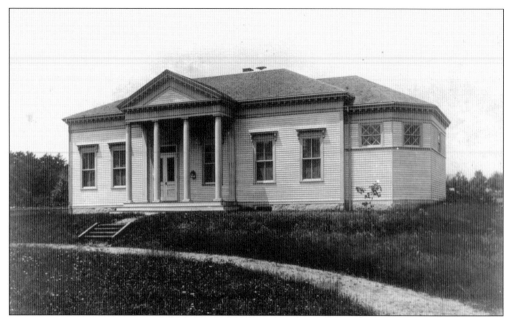

The present-day parish house of the North Community Church was originally the Clift Rodgers Library. Rodgers was a leather merchant who, in 1897, left $5,000 to incorporate a library in Marshfield Hills. An earlier library had been located in the North School. In 1950, the Clift Rodgers Library collection was moved to what was then the Community Church parish house on Pleasant Street where the library is located today.

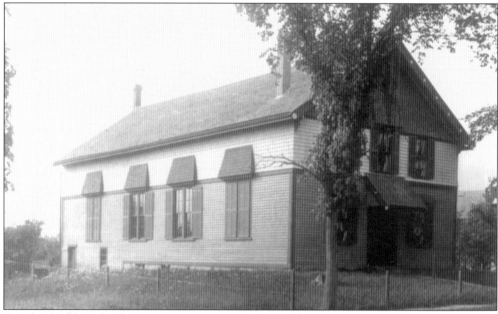

Another building that has seen many uses is today's North River Arts Center. In 1826, a part of this building was moved here from Center Marshfield where it had been an Episcopal church. It later became a paint and wheelwright shop and then was rented out as Rogers' Hall. In 1892, it was dedicated as the David Church Post 189 of the Grand Army of the Republic (GAR), known for many years as the GAR Hall. It served as a theater in the 1920s and 1930s.

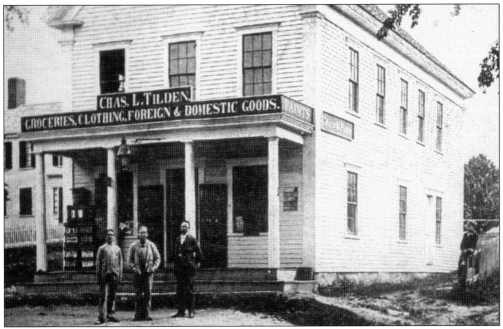

Charles L. Tilden built and opened this store in the 1890s. It was located in front of his family house at today's 543 Pleasant Street. He sold groceries, grain, tools, seeds, shoes, and dry goods and captained a North River packet ship on which he transported his goods. In 1919, the building was moved across the street and converted into the parish house of the Second Congregational Church. It is now the Clift Rodgers Library.

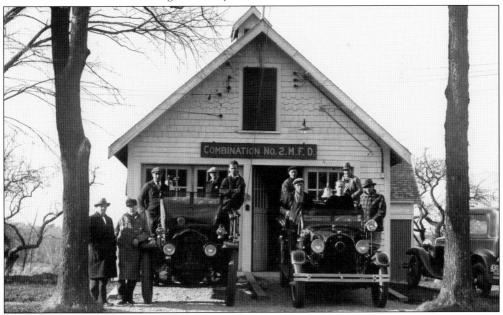

At one time, this was the firehouse of Combination No. 2 Marshfield Fire Department, an all-volunteer group of men of the Hills including Damons, Phillips, Fords, and Ainslies. The building still stands on Old Main Street. It is owned by the town and used by the North River Arts Association for art exhibits at the annual Arts Festival in May.

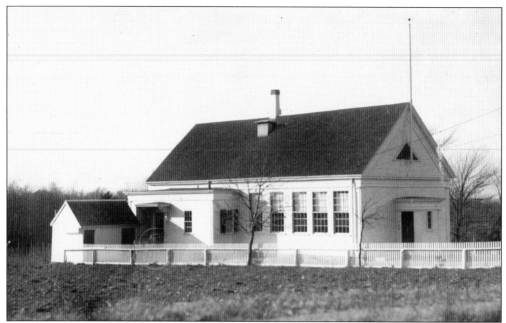

The North School, built in 1838, was for over 100 years a two-room grammar school accommodating the first to eighth grade levels. It was 1 of 12 district schools that existed from time to time in the town. The first Marshfield high school was located here in 1889. The building was turned over to the fire department and remodeled in 1954 as the Marshfield Hills fire station.

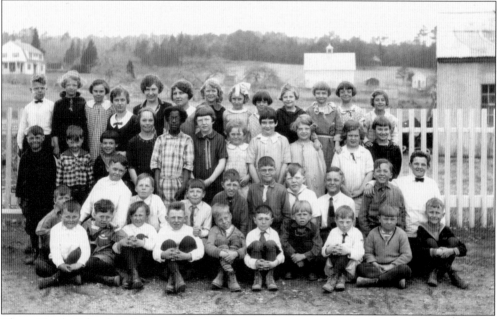

These North School students occupied two rooms, one accommodating grades one through three, the other grades four through six. Two teachers taught and managed the whole group. Education was disciplined but progressive with younger students exposed to older students' material, and thus able, in some cases, to move up a grade level.

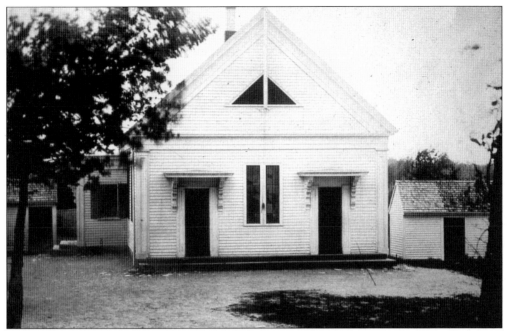

The North School seen here had two entrances, one for the boys and one for the girls. School sessions were held in private homes in the north part of the town as early as the 1750s. From time to time, school buildings were designated in various locations in the village until the North School was built as a permanent school in 1838.

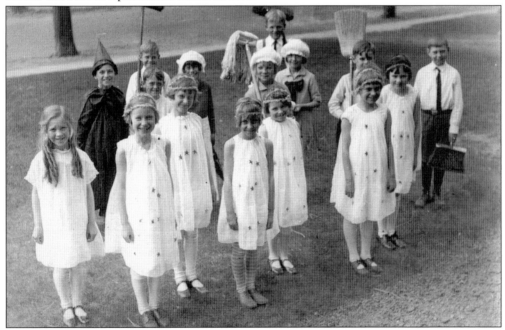

Lots of programs and activities were held at the North School, such as this pageant of the 1920s. The children had special music and art instructors and staged plays and musicals. The last session of the North School was held in 1951, but the district school returned when the Eames Way School opened in 1961 with 327 students.

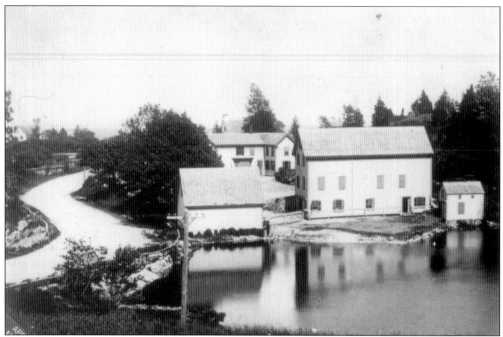

Here can be seen Summer Street at the foot of Prospect Hill. Walker's Pond at the right was named for Charles Walker, who ran a nail and tack factory here by 1838. Nail manufacturing was done on many of the ponds of Marshfield after the invention of the nail-making machine by a local man named Jesse Reed in 1807.

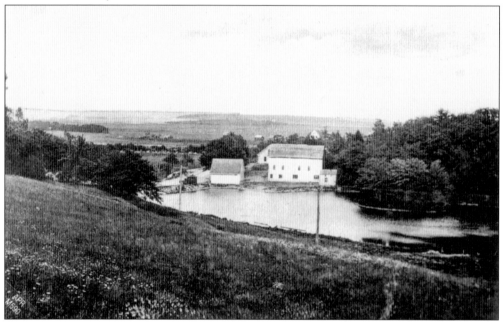

Walker's Pond was the site of a number of different milling operations over the years. Joshua and Deacon Samuel Tilden ran a sawmill here about 1793. Later there was a grist mill run by Charles Lewis. In the 1900s, Tom Stackhouse cut and stored ice in the barn seen here. The pond became known as Stackhouse Pond and was later called Savage's Pond for a nearby family.

In this view at the foot of Prospect Hill can be seen not only a piece of Walker's Pond but the area now called Murdock's Pond. This pond was created in 1958 by John A. Murdock, who developed the adjacent area. Before that it was a tidal marsh, good for swimming on a hot summer day. In the distance can be seen the train on the track that is today Damon's Point Road.

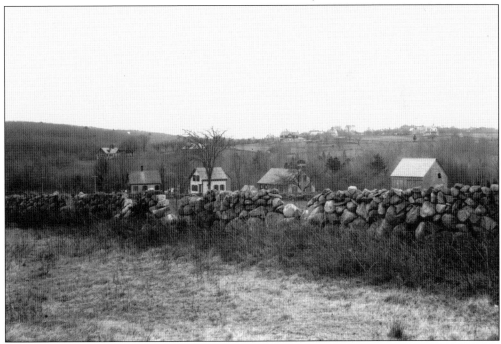

This is a view of Prospect Hill taken from the top of the Summer Street hill. Summer Street runs just behind the stone wall in the foreground. In the far distance can be seen some of the houses in Marshfield Hills village. The row of Summer Street houses still stand today, but the little shed at the right is no longer there.

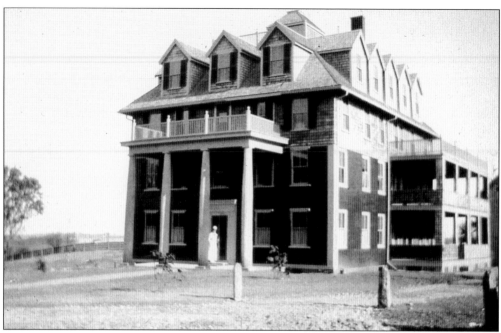

Who would recognize this as the original South Shore Hospital? Founded by Dr. Seth Strong in the late 19th century, it was the forerunner of today's hospital in Weymouth. It was located on Summer Street across from the recent Torrey Little Auction Barn. Prior to being a hospital, the building was the home of the Trouant family. The abandoned hospital burned in March 1934.

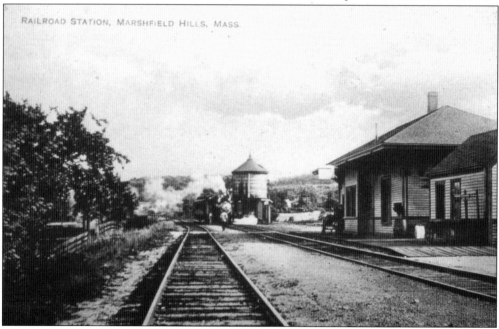

The Marshfield Hills railroad station was the first stop in Marshfield after crossing the North River from Scituate. The train tracks were extended to Marshfield in 1870 and discontinued in 1939. There were five stations in the town. Here can be seen the standpipe where water, piped down Beare's Brook from Wales Pond on Pleasant Street, was stored for the steam engines.

Seven
ALONG THE NORTH RIVER

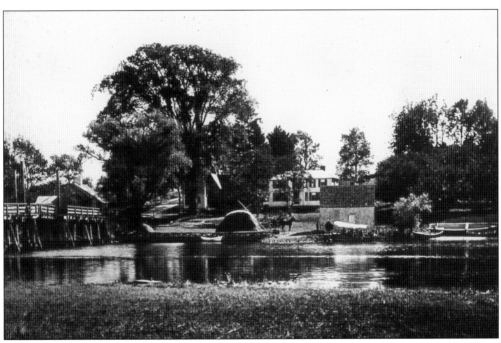

People today recognize this scene as Mary's Boat Yard but it has seen many other activities. Here was located one of the Rogers' shipyards. Ships were built here that sailed to every port in the world. Far to the right can be seen a long, flat-bottomed boat called a gundalow used to harvest salt hay from the river meadows. In the center is the 1720 Rogers house.

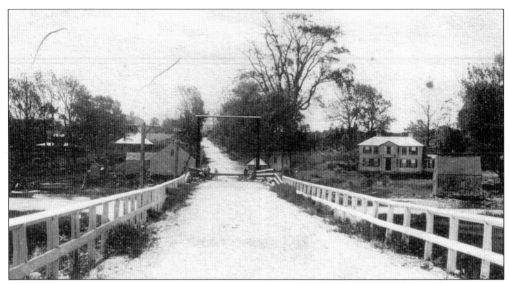

After 1825, travelers coming from Scituate into Marshfield could cross Little's Bridge at today's Route 3A. This bridge replaced Vassell's Ferry that operated here from the 1650s. Little's Bridge was a toll bridge until 1865. The story goes that when the ministers of each town exchanged pulpits they would swap horses in the middle of this bridge to avoid the toll.

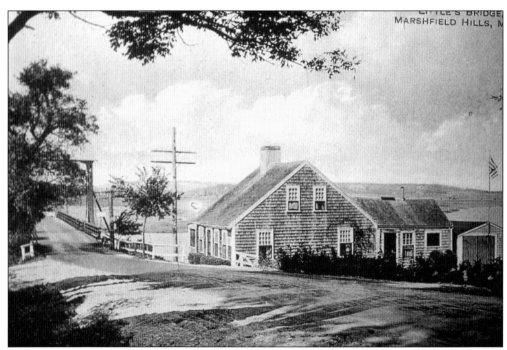

The tollhouse keeper's house was located to the right of the road approaching the bridge. This building was later moved to Summer Street where it is today. The North River that flows by this site was a bustling scene of activity during the shipbuilding years from the 1650s to the 1850s. The Rogers built and owned packet ships that carried on a lucrative trade with Boston.

This house at Summer Street and Main Street (Route 3A) is today the Massachusetts Audubon Society South Shore Sanctuaries regional office. It was built about 1854 on property once belonging to the Little family for whom Little's Bridge was named. The area has been known as Stoddard's Corner for Enos Stoddard and recently as the home of his descendants Connie Killam and Betty Killam Rodgers.

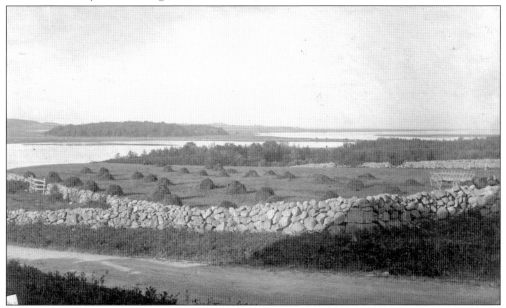

The fields stretching down to the North River from the Audubon Center on Summer Street were once pastures and hay fields. They are now the site of the Audubon Society's nature trails. The North River was named by the Pilgrims at Plymouth since it was the northern most river in their territory. Native Americans used the river as a waterway across southeastern Massachusetts.

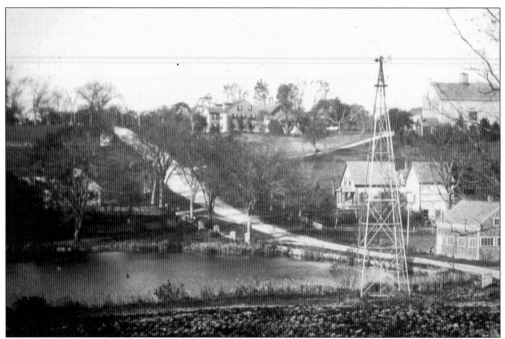

Today this is called the Highland Street hill, but for years it was known as Moses Rogers Hill and later as Nelson's Hill. The Rogers homestead, shown here at the top of the hill, was built about 1660 and is one of the oldest houses in Marshfield. On Damon's Pond at the foot of the hill there have been many mills, an ice cream factory, a candy factory, and an ice-cutting operation.

Union Street in North Marshfield was named because it connected the towns of Scituate, Marshfield, and Pembroke. From 1640 to 1788, a piece of land two-miles long and one-mile wide in this area was owned by Scituate and even today is called the "Two Mile." Here lived the Oakman, Hatch, Little, Tilden, Magoun, and Rogers families. All were farmers, some were millers and some built ships.

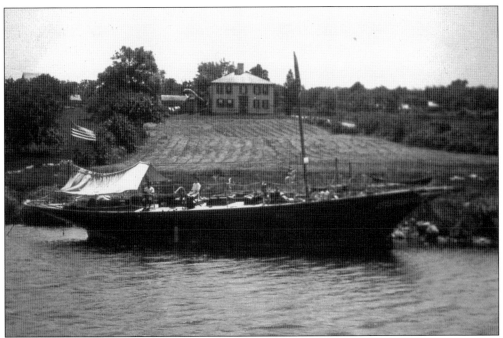

The old Hatch Tilden house stands guard over Marshfield at the Union Street Bridge. Just behind the house is the Elisha Bisbee homestead. Bisbee came from Scituate in 1644 to run the Upper Ferry at this site. He was a farmer and a shoemaker. The vessel in the foreground is possibly on its way down river to be rigged and outfitted at White's Ferry shipyard at Humarock.

A toll drawbridge was first built at this Upper Ferry site in 1801. Hatch Tilden was the toll keeper from 1808 to 1850, when it became a free bridge. A new bridge was built in 1898 but was washed out by a winter ice storm in 1917 when another bridge was built. The present bridge was constructed in 1971 as a drawbridge that has never been functional.

Girl Scout Camp Wy Sibo was a popular day camp off Union Street, North Marshfield, during the 1930s and 1940s. Run by the Marshfield Girl Scout Council, it was held at the log cabin on the hill behind the farm of Tracy and Betty Hatch. It offered outdoor activities, swimming lessons in the North River, canoeing, nature walks, and camp lore under a dedicated staff of councilors.

At Camp Wy Sibo, every day started and finished around the flagpole. The Girl Scout pledge was recited, the flag saluted, and the day's activities outlined. Seen here is a group doing acrobatics before perhaps heading off for archery lessons or camp crafts. Favorite activities were swimming and boating on the river and singing and cooking s'mores over the campfire.

Rob Tilden and his wife, Dorothy Phillips Tilden, ran a farm on Highland Street hill. Their specialty was tomatoes that they grew in the fields and in several large greenhouses. Rob was known for wrapping each tomato separately and personally driving his produce to the Boston market. Rob's daughter Doris Tilden married the well-known auctioneer W. Torrey Little.

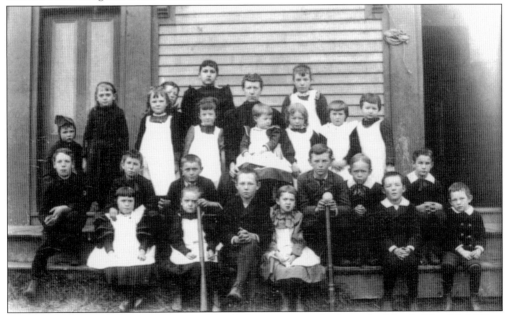

These children attended the Union School that once stood where the North Marshfield Post Office is today. A schoolhouse was located here by 1838. It was sold in 1847, and a new one was built. When the school closed in 1920, there were 17 pupils in grades one through five. The building was bought by Rob Tilden in 1922 and became a barn on his property.

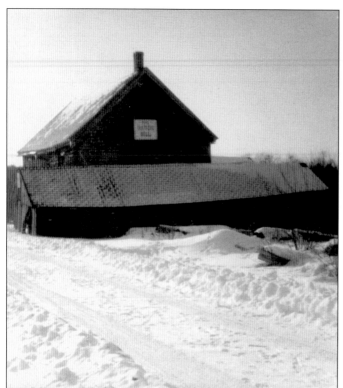

The Hatch Mill was one of several mills on Two Mile Brook that flows into the North River at North Marshfield. It is today the only mill still standing of the many mills that once operated along the brook. The original settler, Walter Hatch, came to live here as early as 1647 and many generations of Hatches have lived in the area since. At one time, it was known as Hatchville.

The Hatch Mill was owned and operated by the same Hatch family, father to son, for over 150 years until 1965. Decker Hatch, last of the Two Mile millers, sold the mill to Robert Reed. In 1968, it was purchased by the Marshfield Historical Society. A long but unsuccessful effort was made to restore the mill to an operating up-and-down sawmill in the 1970s.

Here are Hatch and Pearl Whittaker, president of the Marshfield Historical Society during the 1970s. The long, low shed is the oldest part of the mill and dates to 1812. Decker ran a circular saw operation here that replaced an earlier up-and-down saw. From time to time, the mill was used as a grist mill and at one time was a fulling mill.

Decker Hatch with his wife, Anne, is working here in his garden, a job he loved to do. The Hatches were farmers as well as millers in these fertile fields along the river valley. Decker also owned and farmed a number of wood lots along Pine Street. These lots supplied the timber for the milling and shipbuilding that once prospered along the North River.

The Hatch Mill pond is one of four dammed-up ponds along Two Mile Brook. At one time, the water was used to operate as many as two mills on each pond simultaneously. Three of the mill sites were owned by Hatches and the upper site by the Magouns. Today the restoration of the Hatch Mill is being undertaken by the Hatch Mill Restoration and Preservation Group, one of many organizations working around town to keep Marshfield history alive.

Eight
Around the Town that Was

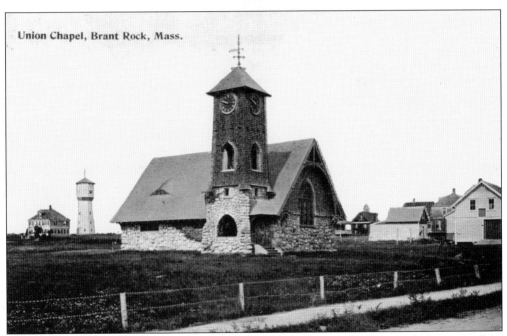

Some day, the Brant Rock Union Chapel will crumble, and a bit of Marshfield history will be lost. For now, though, and certainly hopefully well into the future, the signature stone edifice of that village stands as a link between the present and the past, a scene as readily visible to a postcard purchaser 100 years ago as it is to a youngster visiting the beach for the first time today.

Marshfield was built on the backs of farmers and fishermen, people who either lived off the land or the sea or, in some cases, both. Many of the old traditional means of subsistence are now gone or on their way out. Bittersweet cranberry harvests once contributed significantly to the town's economy. Some can still be seen today

While many of the industries have come and gone, many of the old Marshfield families have stayed on, pursuing new lines of work in town, preferring to maintain ancestral homesteads rather than forge a life elsewhere. The photographs on this page are of the ancestors of Ken Rand, owner of Rand-Handy Oil on Webster Street in 2006.

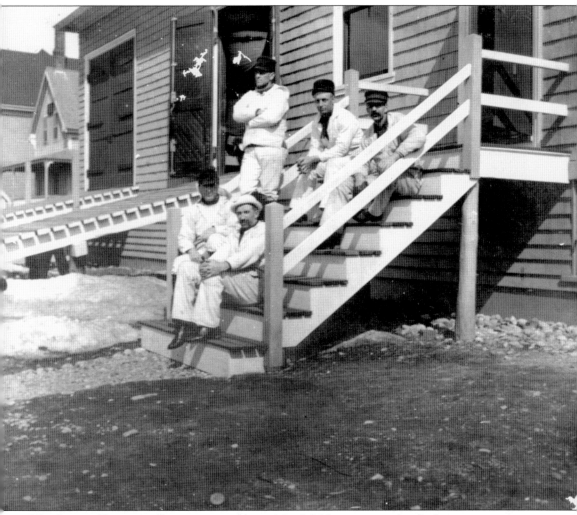

The forces of history will continue to change Marshfield, sometimes for the better, sometimes for the worse. When the U.S. Life Saving Service came to the new Brant Rock station in 1893, the locals had every reason to believe that some form of the crew, here shown outside the station in their summer whites, would be around forever. But Keeper Benjamin T. Manter and his surfmen arrived at a time when lifeboats were powered by oars and men walked the beaches with lanterns in search of shipwrecks. As the federal organization believed each such crew could cover approximately two and a half miles in each direction along the beach, crews were also stationed at Fourth Cliff in Scituate and at Gurnet Point in Plymouth at the end of Duxbury Beach. Better communication and boat propulsion systems, however, made beach patrols and rowboats obsolete. Ship-to-shore radios, radar, and motor surfboats shrunk time and distance, and one by one the stations of the old Life Saving Service disappeared. Today an empty lot across from the Brant Rock Chapel is all that remains in memory of the station that the Victorians saw as the cutting edge of advancement in the rescue of mariners in distress at sea.

Mother Nature will see to it that Marshfield continues to evolve over time. Although technically this view is of Scituate, it has significance that reverberates throughout Marshfield's long history. The North River was a world unto itself for nearly 200 years, when shipbuilders of Scituate, South Scituate (now Norwell), Pembroke, Hanover, and Marshfield launched 1,025 ships from its banks. At that time, between the laying of the first keel as early as 1645 and the christening of the last ship in 1871, the mouth of the North River and the South River was at Rexhame. During the Portland Gale of 1898, the North River, aided by the wrathful winds of Mother Nature, blasted apart the barrier beach between Scituate's Third and Fourth Cliffs, shown here, allowing that waterway to flow directly between those points to the sea. In the following years, when the old mouth at Rexhame silted shut, what once was known as the final southward stretch of the North River became instead the final northward stretch of the South River.

No matter what Mother Nature or the forces of history have to say, some things will remain the same for years to come. As long as the ocean meets the Marshfield shore, the residents, like the girls of Camp Wy Sibo, shown here, will enjoy the outdoor life in the warmer months.

So long as there is a Marshfield, there will be entrepreneurs like Rob Tilden, shown here in the middle, to make the most of the opportunities that life in the town offers.

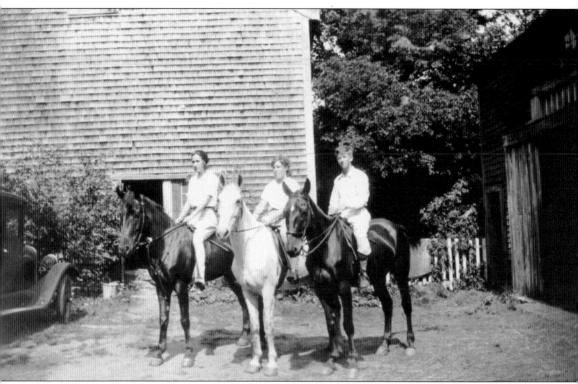

Heroes will continue to arise from the streets of Marshfield, be they the dusty roads of the past or the paved passageways of the present. Walton Rodgers, shown here with friends Barbara Young on the left and Natalie Loomis in the middle, lived with his mother at the Killam-Rodgers estate on Summer Street, in what is now the caretakers' cottage of the Massachusetts Audubon Society's North River Wildlife Sanctuary. When the call went out for troops to fight in World War II, Rodgers, like many Marshfield men and women, answered patriotically. Sadly a plane he was on vanished over the Pacific, and his body was never found. His mother, Betty Killam-Rodgers, after hearing he was listed as missing in action, waited for 10 years for him to return. After those 10 lonely years, she moved into the main house. She passed away in 1975.

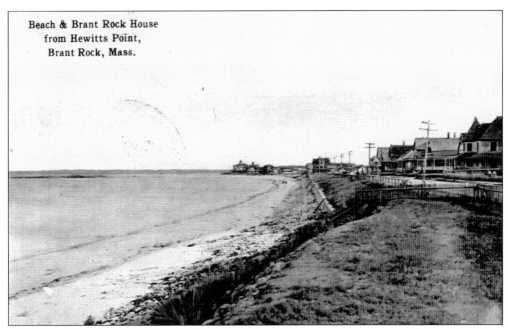

Beach & Brant Rock House from Hewitts Point, Brant Rock, Mass.

Inland dwellers who seek respite from the dry days of summer will continue to flock to the shore, giving Marshfield a chance for renewal and change every year, as new people discover the beauty of the community. Some will buy or build homes in Marshfield, others will just pass through. When each summer is over, the town will belong to the locals again.

The beauty of the landscape will remain. Homes and businesses will come and go, but the undulating hills and the winding rivers upon and near which they are built will stay. The protection of hundreds of acres of open land by local, state, and regional agencies mean that scenes like this one on Island Road, though now gone, can still be seen in other parts of Marshfield.

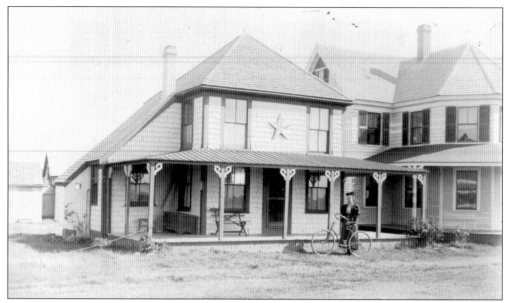

Trends will come and go, as evidenced by this unnamed house in a picture in the town archives. The large star dividing the windows on the second floor was a 19th century accessory; in 2005, similar stars began reappearing on houses in Marshfield.

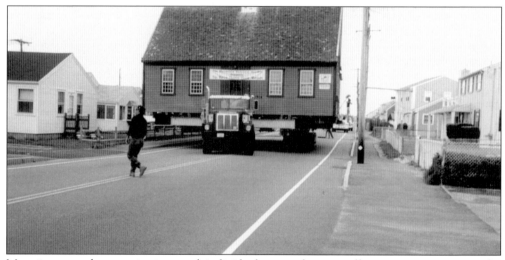

Most importantly, organizations and individuals around town will continue to preserve the history of Marshfield, be it through public lectures, publications such as this one, or the relocation and restoration of historic buildings like the Marcia Thomas House, shown here. It is now the headquarters of the Marshfield Historical Society on Webster Street.

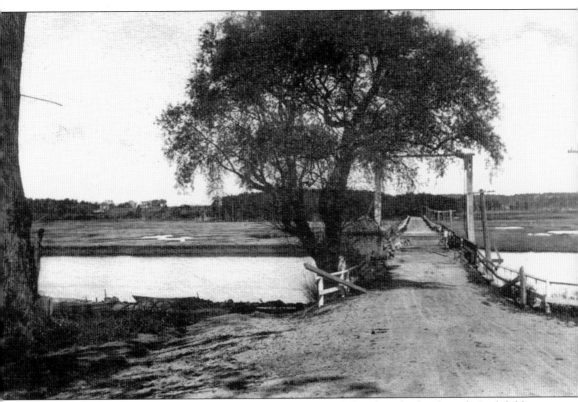

For many people in the late 19th century, life began and ended within the borders of Marshfield. For when one thought about it, where else did one really need to be? Marshfield had hills, and it had ponds. It had three large rivers, and plenty of smaller brooks and streams. It had beachfront, parades, hotels, great fishing, and a world class agricultural fair. Life was good in Marshfield. It was for many, as naturalist Henry David Thoreau once described his hometown of Concord, the most estimable place on earth. If for any reason, one wanted to leave Marshfield for the busy streets of Boston, Main Street took one directly to the banks of the North River and to this bridge leading across to Scituate, a place with its own distinct history and culture. From there, it was north to the city. Many people left, while others remained. When one thinks about it, the Marshfield of today, though changing with the times, retains much of the character of days gone by.

www.arcadiapublishing.com

Discover books about the town where you grew up, the cities where your friends and families live, the town where your parents met, or even that retirement spot you've been dreaming about. Our Web site provides history lovers with exclusive deals, advanced notification about new titles, e-mail alerts of author events, and much more.

Arcadia Publishing, the leading local history publisher in the United States, is committed to making history accessible and meaningful through publishing books that celebrate and preserve the heritage of America's people and places. Consistent with our mission to preserve history on a local level, this book was printed in South Carolina on American-made paper and manufactured entirely in the United States.

This book carries the accredited Forest Stewardship Council (FSC) label and is printed on 100 percent FSC-certified paper. Products carrying the FSC label are independently certified to assure consumers that they come from forests that are managed to meet the social, economic, and ecological needs of present and future generations.

FSC
Mixed Sources
Product group from well-managed forests and other controlled sources

Cert no. SW-COC-001530
www.fsc.org
© 1996 Forest Stewardship Council

Find Your Place in History.